IMPRESSIONIST MASTERPIECES
IN AMERICAN MUSEUMS

IMPRESSIONIST MASTERPIECES
IN AMERICAN MUSEUMS

Robert Boardingham

HUGH LAUTER LEVIN ASSOCIATES, INC.

Copyright © 1996 Hugh Lauter Levin Associates, Inc.
Introduction "The Wilderness in the Garden" © 1996
by Alexandra Bonfante-Warren.
Design by Ken Scaglia
ISBN 0-88363-156-3
Printed in China

Contents

Acknowledgments

 edicated to my parents, Robert and Patricia

I am especially grateful to the staff of Hugh Lauter Levin Associates. Leslie Carola, chief editor, put immense effort into this book and made numerous excellent suggestions. Without Leslie's good sense and remarkable patience, this text would not have been completed. Her good will is matched only by her professionalism and hard work. The skillful editing of Alarik Skarstrom and Deborah Zindell greatly improved the prose. James Muschett gathered the reproductions in very short order.

Conceived and written as a popular introductory survey of Impressionism culled from American museums, I am nevertheless grateful to several experts in the field. In particular the recent scholarship of Richard Brettell, T. J. Clark, John House, Richard Kendall, Henri Loyrette, Joachim Pissarro, Joseph Rishel, Gary Tinterow, Paul Tucker, Richard Shiff, Charles Stuckey, and Henri Zerner would have been cited often if the book included notes. Three individuals provided insights as intelligent and tough general readers: Robert Mitchell, Elizabeth Radow, and Christopher Sultan. Charles Cumella contributed his good humor during the writing. I cannot imagine more generous friends.

At the Museum of Fine Arts, I am deeply appreciative of several people's efforts. Scott M. Black's shared enthusiasm for French modernist painting is a source of ongoing inspiration as he continues to build his collection and share it with the New England public. Deanna Griffen, Department Assistant, worked evenings and weekends to help prepare the manuscript. I am particularly grateful to Erica Hirshler, Assistant Curator of American Paintings; George T. M. Shackelford, Mrs. Russell W. Baker Curator of European Paintings; and Barbara Stern Shapiro, Curator for Development Projects, for their helpful criticisms and support.

My greatest debt is to my brother Brian. During difficult circumstances, he offered constant encouragement and excellent advice, supported by Christine, my sister-in-law, who shared her husband with me during her pregnancy with their first child, my first nephew, Brendan.

Introduction: The Wilderness in the Garden

*I*n Edith Wharton's novel *The Age of Innocence*, set in the Old New York of the 1870s, Newland Archer makes his way toward the Beauforts' *"bouton d'or* drawing room (where Beaufort had had the audacity to hang 'Love Victorious,' the much-discussed nude of Bouguereau)." Old New York would have been scandalized by the new art, no matter how innocent or earnest, but its own mores force it to swallow the nicely aimed, if transparently encoded transgression to which Beaufort has given pride of place—Bouguereau was, after all, an unexceptionable artist, known for academic (read *de facto* respectable) treatments of religious subjects, as well as allegories such as 'Love Victorious.'

Wharton's portrait of Beaufort's audacity was sure to give her readers occasion to smile, in the New New York of 1920, the year *The Age of Innocence* was published. Affronted prudery was quaint, compared with the shocks delivered by the art of the fifty years since the Beauforts' fictional ball. Wharton could be confident that her audience would be aware of the Société Anonyme's Impressionist exhibition of 1874, just one more symptom of the modernism that was massing against Newland Archer's brittle social universe.

In 1920, Mary Cassatt, the American among the French Impressionists, was alive, though she had painted little since the period of World War I, owing to her failing eyesight. She had arrived in Paris in 1866; in 1872 she exhibited in the official Salon. In 1879, she showed in the fourth exhibition of the Groupe d'artistes indépendants; one of the conditions for inclusion in the show was a commitment not to enter work in the Salon. That same year, the Society of American Artists held its second annual exhibition—Mary Cassatt's *At the Opera* (see page 75) of that year was exhibited there. In it, Cassatt was portraying the world to which she was born, yet by addressing her subject in an Impressionist mode, she was also presenting it subtly from without.

Cassatt was the perfect ambassador to the United States for the new art: herself an artist, she could explain these arcane expressions that played tricks with perception and materiality, while as an American aristocrat—a quality that helped the French critical establishment take her seriously—Cassatt could enlist her peers' financial support of the Impressionist movement without the crass taint of trade. In particular, Cassatt's friendship with Louisine Elder, the future Mrs. H.O. Havemeyer, was one of the avenues along which the works of these early moderns entered private collections in the United States and, eventually, the holdings of museums throughout the country.

Impressionist works appeared early and continually in the United States, not only through Cassatt's mediation. Paul Durand-Ruel, who was to become one of the most influential figures in the art world of his time, had loved the Impressionists from their beginnings, often purchasing their works for his own collection as well as for resale. In 1886, Durand-Ruel sponsored an Impressionist exhibition in New York City; he was also instrumental in introducing the school to Chicago, whose Art Institute holds several important Impressionist works. In 1896, the Carnegie Institute inaugurated the first of a series of international exhibitions that featured a number of established French painters, including those of the Salon, but also Degas and Monet. Four years later, the exhibition again invited works by these artists; in addition, the Carnegie presented paintings by Cassatt, Sisley, Pissarro, and others.

The end of the nineteenth century was a period of civic philanthropy, when oil and railroad money

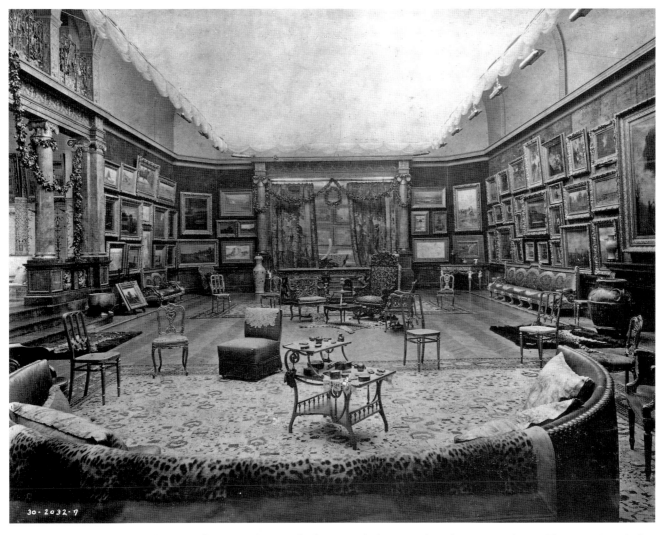

Main gallery, the Potter Palmer residence in Chicago, looking south from north end, c. 1900. Photo: Chicago Historical Society. The Potter Palmers were prominent American collectors of French Impressionist art.

endowed libraries and museums and funded parks for the betterment and productive leisure of the working classes. Durand-Ruel was well aware of the opportunities the new museums afforded for presenting the new art. In 1905, the dealer made the Toledo Museum, founded in 1901, the first stop on a exhibition that was to tour for almost the rest of the decade; besides paintings by Cassatt, Degas, Manet, Monet, Renoir, Pissarro, Puvis de Chavannes, and Sisley, the dealer presented works by artists virtually unknown today, such as Albert André, Maxime Maufra, and Federico Zandomeneghi. The variety of artists also meant a range of prices: Durand-Ruel was a very good dealer. For decades, museums purchased only single works by a few artists, but by the end of her lifetime, in 1926, Cassatt's native country boasted a truly representative array of these ground-breaking artists.

In the 1870s, the East Coast art-buying class was traveling to Europe as a matter of course, bringing home contemporary academic art from England and France especially. England, with its increasingly impoverished and marriageable nobility, was still the model for American Society, while Paris was necessary for the requisite dressmaking. It was also thrillingly but safely "foreign," and one of the speakable thrills of that wicked city was the art that was challenging the academy. Impressionism made claims about visual accuracy and sensory truth, and pursued these aims into color harmonies sometimes deemed grotesque, and subject matter often judged tasteless.

The history of representation has never been unembattled, just as illusionism has never been an unambiguous proposition. An apocryphal tale relates that the fifth-century B.C. Greek painter Zeuxis made a

picture of a bunch of grapes so lifelike that birds attempted to eat them; behind this story are questions about the relation of art to reality that endure to this day.

The invention of photography in 1839 brought a number of these questions to the fore. What was painterly skill to photography's flawless silver finish? Why pay more for a painted portrait, when a portrait photograph was more true to life? Photography—a medium paradigmatically in the right place at the right time, as the United States population increased, and with it the middle class—shouldered out those modest itinerant portraitists who served the less prosperous and left behind touching traces of pre-Civil War American art.

Americans were also seeing photographs of their countryside, such as those from the post-Civil War Wheeler surveys. Yet, perhaps because of the Puritan legacy, what the public was missing in landscape photography was order, an organizing point of view that prewar artists such as Asher B. Durand, the German-born Albert Bierstadt, and the British-born Thomas Cole had brought to otherwise dauntingly majestic views. Nature, then as now, was an uneasy force, all the more so in a nation pursuing a destiny not unarguably manifest. One of the characteristics of the art of the Western United States was Nature as a protagonist—even when landscape was shown tamed, as the ancient Romans in their triumphs displayed their vanquished enemies. To many Americans, however, especially in the East, all that raw bigness was, literally, behind them, as they steadfastly looked to Europe, themselves a civilized nation with only a slight inferiority complex.

In Europe, landscape was traditionally heavy with association. Whether background to stories of saints and emperors, Romantic projection of the sensibility of singular souls, or portrait of the nobility's holdings, landscape was often either more or less than itself. Impressionism, for all its radical techniques and subjects, was at heart a bourgeois art, in that it sought to capture a temporal, physical moment—a slice of life. That choice of instant was what early photography could not yet give.

The idea of Impressionism often conjures up the outdoors, easels *en plein air*, and Claude Monet painting against the sun's passage, in pursuit of light's transient effects. This fresh air was one of the legacies of the Impressionists' forebears, the members of the Barbizon School, those intrepid trailblazers who ventured out of their north-lit studios. Sometimes the Impressionists made landscapes, such as Pissarro's *Climbing Path, L'Hermitage, Pontoise* (see page 57). More often, the outdoors is integrated into scenes of human activity—rural doings or the city-dwelling middle or upper classes at play, such as Auguste Renoir's *The Luncheon of the Boating Party* (see page 87). In any case, there is nothing picturesque, much less sentimental, about a work such as Monet's *Grainstack (Snow Effect)* (see page 100); it is straight-ahead, hard-won realism.

At least as characteristic, however, and intersecting with the exurban representations are what have come to be considered the proper subject of modern realism: the city scenes. Auguste Renoir's *Pont des Arts* (see page 29), Berthe Morisot's *View of Paris from the Trocadero* (see page 41), Monet's *Boulevard des Capucines* (see page 51), Gustave Caillebotte's *Paris Street: A Rainy Day* (see page. 69), and Edgar Degas's *The Millinery Shop* (see page 93) are some of the examples in this volume of the Impressionists' fascination with daily human life. (Even Monet's seaside vistas are often towns, and his gardens are only a suburban step or two from the city.) To the folks in the cities of the American East Coast, with their summer and other country homes, such pictures of the world may have been the equivalent of a traditional landscape painting to a member of the landed classes: a portrait of a place that mirrored, identified, and situated the viewer.

The realism that was becoming naturalism in the literature of the last quarter of the nineteenth century was surfacing in the visual arts as well. In France, after 1871, democracy—or at least the

Girard. *The March of Silenus*. 1861. Oil on canvas; 113 × 147 cm; École nationale Supérieure de Beaux-Arts, Paris. Winner of the Prix de Rome in 1861, this painting exemplifies the style, techniques, and subject matter of traditional, Salon-acceptable paintings.

bourgeoisie—was the order of the day, something of which a financial realist like Monet was well aware. Here, too, photography may have raised the stakes: by the last quarter of the nineteenth century, otherwise sheltered Americans had seen blunt moments of wars and economic misery.

Morisot's *Hanging the Laundry Out to Dry* (see page 55) was distressingly rude, as offensive for its "low" subject matter as for its harsh physical facture (it made the distinction between lady and woman as implicitly clear as Sojourner Truth's celebrated speech did explicitly twenty years earlier). Edgar Degas, one of the leading Impressionists, a master of draftsmanship, and Mary Cassatt's champion, was also thoroughly Victorian: as encoded as Beaufort's nude are Degas's ballet dancers, who, like milliners' assistants, were conventionally believed to be no better than they should be. Driven by his passion to capture life in lines, the society painter of works such as *At the Races in the Countryside* (see page 37) also sketched the world of the brothels he frequented.

Photographs also had implications about another aspect of realism in paintings: the surface of a work of art. Some artists took up the challenge: Rosa Bonheur's animals work patient muscles beneath tired hides, the painting's surface gleaming with a sunlit, seemingly incongrous sleekness. But if a camera—a machine—could best, that is, most precisely, capture the outward appearance of things, it was left to human intelligence and skill to study and render accurately their inner reality, at the same time acknowledging overtly (and paradoxically) the

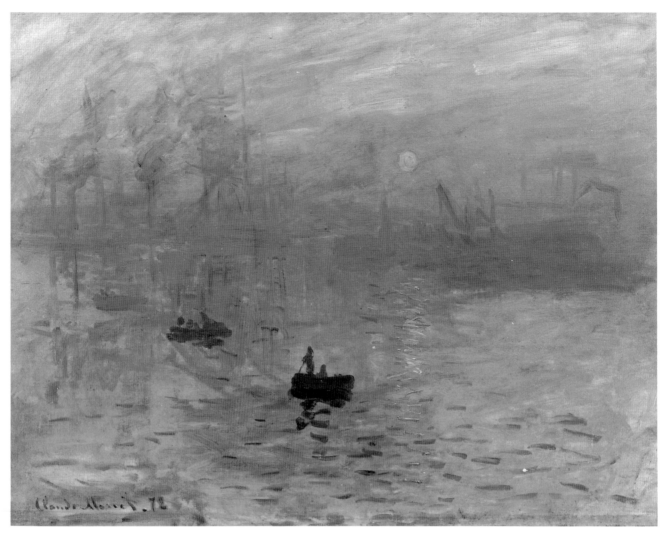

Monet. *Impression: Sunrise.* 1872. Oil on canvas; 48 × 63 cm; Musée Marmottan. The famous picture that gave a name to the new art movement. When asked for a title to put in the catalogue for the first Impressionist group exhibition in 1874, Monet said "Call it Impression." Critic Louis Leroy coined the term "Impressionists" in his unflattering review of the exhibition.

material reality of a painting. In fact, a common criticism of the Impressionists, Renoir and Monet especially, was that their paintings were not finished. What the Impressionists rendered in varying degrees was the study itself, a deconstruction of the process by which we receive and interpret visual information. For several of the Impressionists, art was an experimental pursuit, an attitude fully in keeping with the science and scientism that were the order of the Victorian day.

Of the artists represented in this volume, Georges Seurat was perhaps the one to study the science of painting most earnestly. With Ogden Rood's *Scientific Theory of Colors* in hand, he constructed images that are tours de force of illusionism: we see the dots, but we also see and respond to the image they compose; *Sunday Afternoon on the Island of La*

Grande Jatte (see page 95) is a classic example. (The scientific aspect of the Impressionists' research was a repeated selling point during Durand-Ruel's first American tour.) Auguste Renoir's single-minded hunger for the perfect hues made him one of the most skilled colorists of the Impressionists, though critics have sometimes found his drawing weak and his subjects pedestrian or sentimental. The critic Theodore Druet said of the Impressionists: "Winter is here. The Impressionist paints snow. He sees that, in the sunlight, the shadows on the snow are blue. Without hesitation he paints blue shadows. So the public laughs, roars with laughter."

It may be that the unabashedly unsentimental modernity of the Impressionists touched a chord in a new generation of wealthy Americans. Inspired by their own modernity, they may have seen in

these unprecedented works a reflection of the brave new technological order of railways, oil, and commerce that was so lavishly rewarding its acolytes.

The public's and the critics' opinion mattered, because this generation of artists overall had little other means of support. Cassatt and, to a lesser degree, Manet had private incomes, but many of the group of the Impressionists did not. They were experimenting with the science of painting; they were pursuing personal visions and not, for the most part, commissions. This is one of the reasons why Cassatt's popularization of the Impressionist enterprise was so crucial. Manet, who was often hard up, was also one of the most controversial of the group—witness his *Luncheon on the Grass*, in which he transmutes a classical nude into a prostitute, in an elaborate web of gazes and power relations. And even *Mlle V . . . in the Costume of an Espada* (see page 19) does not censor the erotic aspect of a masquerade.

The Impressionists did not spring fully formed, nor were they monolithically art-world outcasts. Not only had Camille Pissarro's innovative *Jallais Hill, Pontoise* (see page 27) been accepted to the official Salon of 1868, it had also been very successful there. However, many of the critics did laugh at the Impressionsts, as Druet said, and many were either outraged, snide, or dismissive, or else damned with faint praise one or another or the whole varied band. But a number of critics—and buyers—responded immediately and enthusiastically.

Impressionism caught on fairly quickly: by 1880 the art historian and critic Philippe Burty observed that the public no longer came to the Impressionist exhibitions to laugh, but to buy; by the late 1880s Van Gogh would say, "It is just as necessary now to pass through Impressionism as it was once necessary to pass through a studio in Paris"; and by 1890 Monet was able to purchase his home at Giverny.

In her works, Edith Wharton observes with complex and artfully modulated ambivalence the incursion of "new" blood into "old" blood, of an energetic mercantile class into a society in which values had become frozen into meaningless ritual. All around Newland Archer's small tribe the barbarians were massing, making things happen. The barons ran empires; they were the leaders of capitalism, the modern economic order. These were the movers and the shakers. They had caused hundreds of thousands of bodies to lay thousands of miles of track, to raise unquenchable geysers of oil, to transform ore into molten millions, to blast tons of ageless rock into nothingness. They had supported the policies that cleared the land of residents and history and made it ready for farms, industry, settlement, and a history yet to be written. It seems apt that the men and women who shaped the new nation would look to a new art, an art of the cities and of nature contained; an art that emphasized the individual to an unprecedented degree; but, above all, an art that embodied the mysteries and power of matter, process, and transformation.

—Alexandra Bonfante-Warren

References

Richard R. Brettell, "In Search of Modern French Painting," in Impressionism: Selections from Five American Museums (Saint Louis and New York: The Saint Louis Art Museum/Hudson Hills Press, 1989).

Leo Marx, "The American Ideology of Space," in Denatured Visions: Landscape and Culture in the Twentieth Century (New York: The Museum of Modern Art, 1991).

Théodore Druet, *Les Peintres Impressionistes*, Paris: Librairie Parisienne, H. Heymann and J. Pebois, May 1878.

Stream in the Forest

GUSTAVE COURBET

Gustave Courbet, the son of a prosperous winegrower and landowner, was born in the Franche-Comté in the small town of Ornans, on June 10, 1819. In 1839 his father sent him to Paris to study law although Courbet had already decided to become a painter. After brief preparatory work with the successful academic painter Charles Steuben, Courbet left the latter's studio to begin an intense period of independent study. Claiming to be his own teacher, Courbet disavowed the importance of artistic instruction. Courbet was the leading member of the realist movement, and yet his painting technique and his choice of subjects had tremendous import for the future Impressionists during the latter 1860s.

Stream in the Forest.
Gustave Courbet.
1862.
Oil on canvas.
61 ¾ × 44 ⅞ in.
(157 × 114 cm).
Museum of Fine Arts, Boston.
Gift of Mrs. Samuel Parkman Oliver.

The Revolution of 1848, which had deposed Louis-Phillippe, was followed by the establishment of the Second Republic (1848–51). In the aftermath of these events, Courbet produced a series of large-scale works on social subjects challenging conservative aesthetic and political orthodoxies. The painter constructed his own pavilion at the Paris Exposition of 1855, placing a large sign over its entrance that proclaimed "Le Réalisme" (Realism). This was in part a challenge to the official exhibition sponsored by the new and repressive government of Napoleon III. The centerpiece of this pavilion was *The Studio (A Real Allegory Summing up Seven Years of My Artistic Life)*, now in the Musée d'Orsay in Paris. *The Studio* depicts the seated artist, working at his easel, surrounded on his left by the poor and exploited and on his right by his friends and supporters. Presaging the future course of his art, Courbet showed himself painting a landscape, a genre in which he had produced relatively few works. To Courbet's dismay his "Realism" pavilion did not provoke scandal and controversy. Demoralized, he largely abandoned social and political subjects following 1855. Thereafter, landscapes, hunting scenes, and portraits became his principal motifs.

Stream in the Forest was probably painted in the region of Saintonge during Courbet's extended visit from May through September 1862, a trip made with Etienne Baudry, a wealthy young collector. Camille Corot was also a guest of Baudry's, for about twelve days in August 1862; he and Courbet painted side by side during this visit. In fact the vertical format of *Stream in the Forest*, with its grouping of tall trees in the foreground, and dappled light, resembles a painting done by Corot during this visit. Unlike Corot, however, Courbet uses unconventional methods of paint application to create a densely textured surface. This surface is characterized by broken, irregular paint layers, suggesting the use of a palette knife and a sponge or rag to apply pigment, methods that Courbet pioneered.

Courbet's technique gives a strong tactile presence to the landscape. The absence of shadows cast by the stag and the two does in the foliage makes them stand out against the highly textured landscape; they were likely added in his studio at a later time. The motif of deer and other animals in a wilderness was popular during the 1860s and 1870s, and Courbet's use of it here is evidence of his concession to the market and popular taste. During the later 1860s Courbet successfully exhibited variations on this theme at the annual Salon exhibitions.

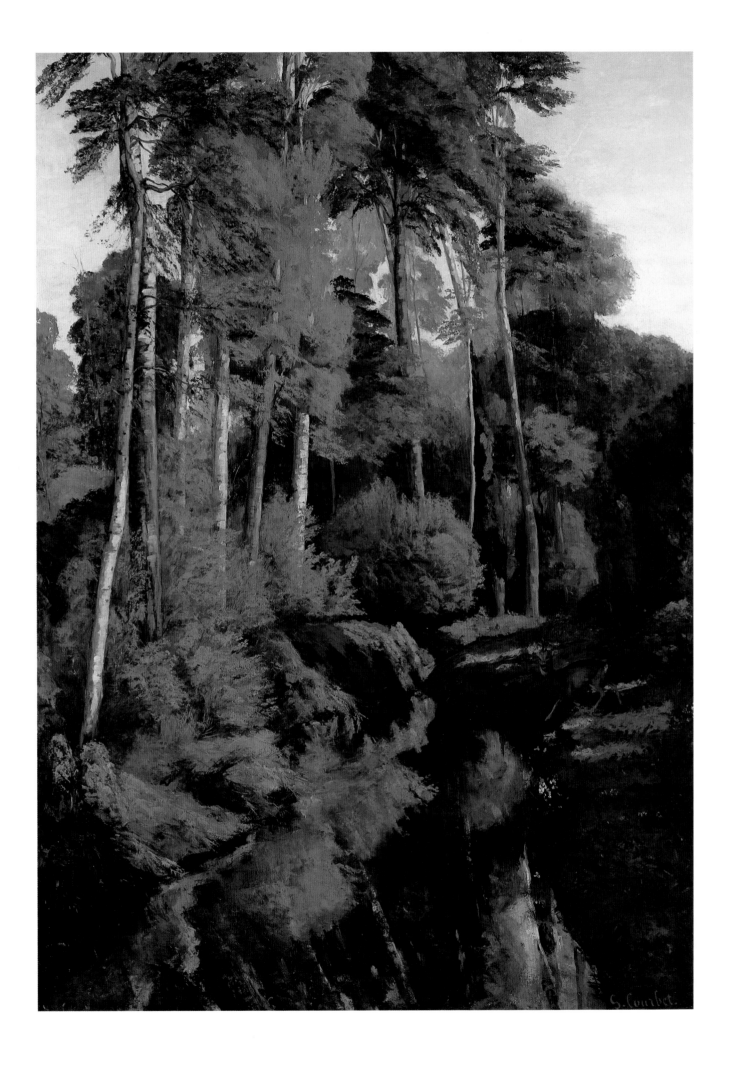

Beach Scene at Trouville

EUGÈNE BOUDIN

Eugène Louis Boudin, born July 12, 1824, was the son of the captain of a small cargo boat. After briefly attending a parochial school in Le Havre, he went to work for a printer and then a stationer. In 1844 Boudin and a partner opened a stationery and art-supply shop that also offered framing services in Le Havre, and it was there that he met the painters Eugène Isabey, Thomas Couture, Constant Troyon, and Jean-François Millet. In 1846 the shop closed and Boudin began to work toward becoming a professional artist. He traveled to Paris in 1847 where, like other aspiring painters, he made copies of the masterworks in the Louvre. The financial support, beginning in 1851, of the Société des Amis des Arts of Le Havre enabled Boudin to study in Paris for three years. He returned to Honfleur and, beginning in 1854, devoted himself to marine paintings of the Normandy coast.

By the mid-1860s, Boudin was submitting landscapes of Brittany and Normandy on a regular basis to the Paris Salons. He rejected the conventional picturesque elements of romantic marine scenes in favor of unembellished nature. At the same time Boudin began to depict a theme that would secure his reputation and provide him with financial success: scenes of fashionably dressed bourgeoisie strolling along the Normandy shore. *Beach Scene at Trouville* is an excellent example of this subject. The casual arrangement — carefully contrived — of figures along the boardwalk and pier suggests a spontaneous moment of upper-class leisure. This momentary and therefore transitory quality is enhanced by the smoke billowing from a ship hidden by the crowd at the pier. The sky, too, is characterized by the sense of a specific instant of coastal weather. Boudin often painted *en plein air* (out-of-doors), and he made numerous studies of clouds and the sky. He is in part responsible for Claude Monet's own interest in atmospheric effects. (Impressed by Monet's caricatures, Boudin had befriended the eighteen-year-old Monet in 1858, encouraging him to paint directly from nature.)

In 1887 Boudin summarized his career for the journal *L'Art*: "Using different genre, I have done all sorts of seascapes and beach scenes in which one may find, if not great art, then at least a sincere attempt at reproducing the world of our time." These attitudes and the fact of working out-of-doors would seem to link Boudin and the Impressionists. And Boudin did participate, a decade later, in the Société Anonyme's first Impressionist exhibition in 1874. However, he never entirely adopted the irregular surface of broken brush strokes or bold palette of Monet and the Impressionists. Another significant difference lay, simply enough, in Boudin's greater financial success. Of the 1874 exhibition, the critic Jules-Antoine Castagnary wrote: "Although some of the artists exhibited are still fighting to be recognized, a certain number have commanded respect for years. One of these is Eugène Boudin, whose beaches and seascapes are being fought over at very high prices."

In 1874, violating an agreement among the members of the Société Anonyme, Boudin also exhibited successsfully at the Salon and thereafter did not participate in any of the subsequent Impressionist group exhibitions.

Beach Scene at Trouville.
Eugène Boudin.
1865.
Oil on panel.
13 3/4 × 22 3/4 in.
(34.9 × 57.8 cm).
The National Gallery of Art,
Washington, D.C.

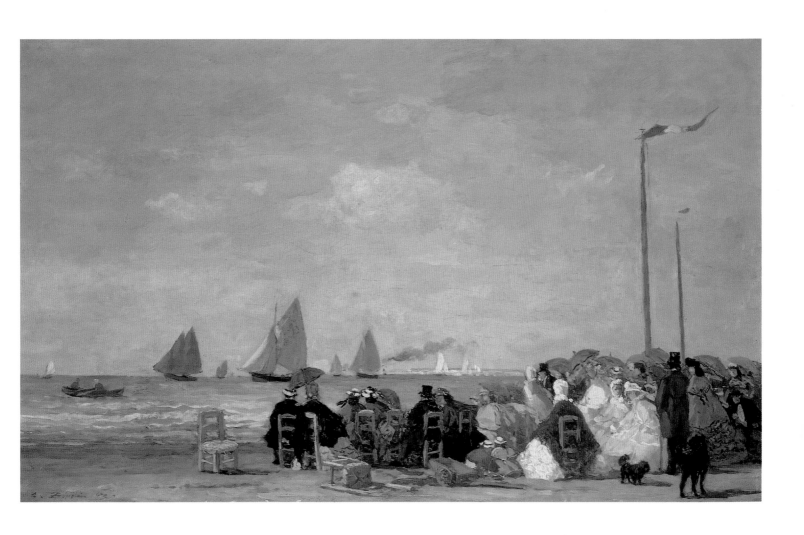

Mlle V... in the Costume of an Espada

EDOUARD MANET

Mlle V... in the Costume of an Espada.
Edouard Manet.
1862.
Oil on canvas.
65 × 50 1/4 in.
(165.1 × 127.7 cm).
The Metropolitan Museum of Art, New York.
The H.O. Havemeyer Collection, 1929.

Edouard Manet was born on January 23, 1832, the son of a prosperous and high-ranking government official. Manet was well educated, and the artist's cultured and cosmopolitan upbringing is clearly reflected in his subtle and complex body of work.

After Manet's father finally consented to let him become an artist, he began his studies with Thomas Couture, a successful and relatively progressive painter. Despite disagreements and quarrels with Couture, he remained in the studio for six years. Manet's first Salon submission was rejected in 1859. Two paintings were accepted by the Salon jury in 1861, one of which, *The Spanish Singer*, now in the collection of The Metropolitan Museum of Art, was awarded an honorable mention. The Salon jury of 1863, however, rejected all three of Manet's submissions; they were subsequently exhibited at the Salon des Refusés, an alternative exhibition mounted as a response to the extreme conservative members of that year's Salon jury. *Luncheon on the Grass*, now at the Musée d'Orsay, provoked a scandal at the exhibition and established Manet's reputation as leader of the Paris avant-garde.

Mlle V... in the Costume of an Espada and *Young Man in the Costume of a Majo*, also in The Metropolitan Museum of Art, were exhibited with *Luncheon on the Grass* at the Salon des Refusés in 1863. All three paintings were radical departures from the traditional expectations for a completed *tableau* (a fully finished painting). Manet was accused of incompetent drawing, faulty perspective, and a crude understanding of color. Moreover, the large-scale pictures did not have elevated subjects or specific narrative or historical references, the themes ordinarily associated with large canvases. The critic Théophile Thoré wrote that Manet's three paintings seemed "as if meant to provoke the public." Indeed, Manet's intentions in painting and exhibiting these pictures were ambitious and polemical.

The most striking feature of *Mlle V... in the Costume of an Espada* is the boldness of Manet's paint application and his palette. Broad strokes of pigment are laid on with extraordinary virtuosity. For example, the chrome orange and zinc white of the cape are handled in a manner that we see more as pigment rather than fabric. The technique draws attention to itself. Moreover, Manet's brushwork varies throughout the picture. The white stockings of the figure are realized in a less cursory manner than the cape. Not only does this textural variance thwart a consistent illusionistic image but it is also clearly a challenge to the mirror-smooth finish of academic painting. Manet's use of color is equally bold. The combination of the orange cape, yellow pocket square, and pink headdress displays his innovative and subtle sense of color. Rather than create an overall surface tonality with subtle gradations of color, Manet has contrasted lights and darks with an unusual and characteristic directness.

Louisine Havemeyer admired Manet's work, and *Mlle V... in the Costume of an Espada* seems to have been her favorite. In her memoirs Mrs. Havemeyer credits this painting as "one of the greatest and most difficult things Manet ever did."

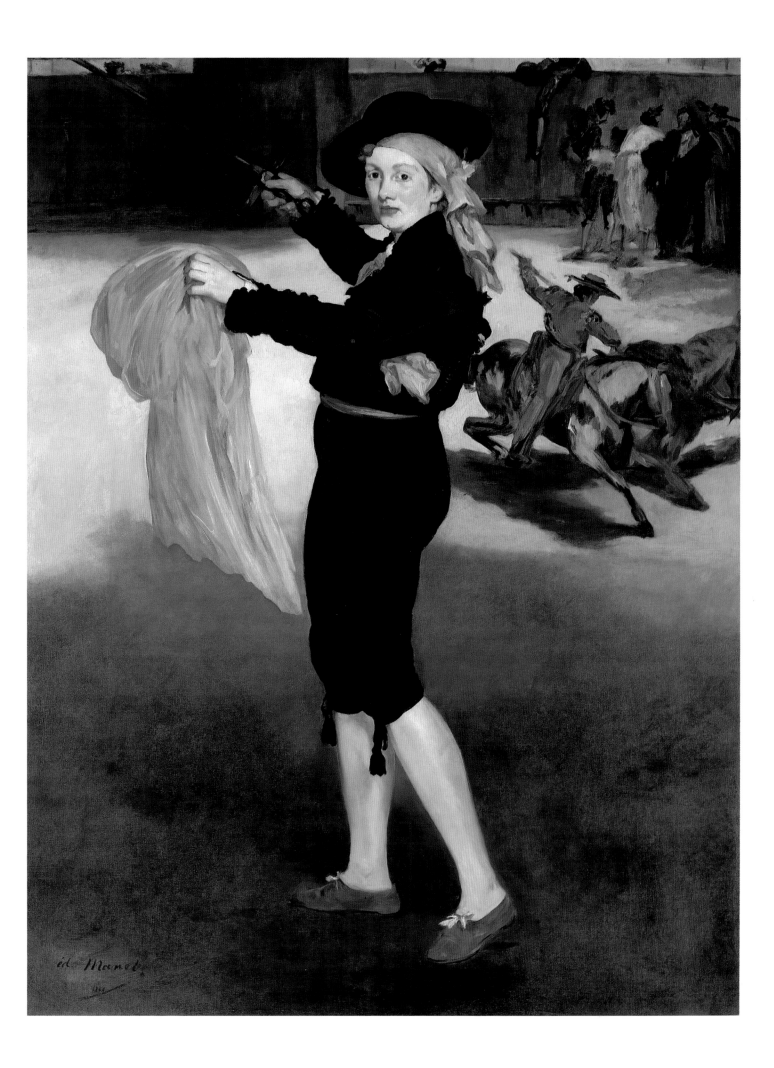

Rue de la Bavolle, Honfleur

CLAUDE MONET

Rue de la Bavolle, Honfleur.
Claude Monet.
c. 1864.
Oil on canvas.
22 × 24 in.
(55.9 × 61 cm).
Museum of Fine Arts, Boston.
Bequest of John T. Spaulding.

Claude Monet was born in Paris on November 14, 1840. His family moved to the Normandy coast around 1845. With his parents' reluctant consent, Monet returned to Paris in 1859 to study painting. The genre painter Auguste Toulmouche, a cousin by marriage, was appointed his guardian in the French capital. At first Monet frequented the Académie Suisse, making drawings of models; at the Salon, he admired the works of Charles-François Daubigny, Constant Troyon, and the Barbizon School. During the winter of 1862–63 Monet entered the studio of Charles Gleyre, an eclectic artist known for his history paintings. Though Monet was unimpressed by the teaching and work of Gleyre, he met Frédéric Bazille, Alfred Sisley, and Auguste Renoir in Gleyre's studio. Monet also spent time at the Brasserie des Martyrs, a meeting place of Courbet and his supporters, and in 1864 he became acquainted with Courbet himself, who played a formative role in the early development of Monet's art. More importantly, however, Monet painted out-of-doors—*en plein air*—in the forest of Fontainebleau for the first time in the spring of 1863 with Bazille.

In May 1864 Monet returned to Honfleur and the Normandy coast with Bazille. Bazille left for Paris sometime in June, but Monet remained in Normandy throughout the summer and fall, painting sites along the Seine estuary in the vicinity of Le Havre and Honfleur. Following Bazille's departure, Monet worked in the company of his early mentors, Eugène Boudin and Johan Barthold Jongkind. But even at that early point the *Rue de la Bavolle* followed a different course from the picturesque canvases of these painters. In spite of Monet's admiration for them and the Barbizon painters, he tried to avoid the sentimentality of their renditions of the Normandy coast and the villages of Chailly and Barbizon in the forest of Fontainebleau.

To his departure from the picturesque, Monet here added his insistence upon the palpable material presence of buildings and the dusty street, an emphasis related to Courbet's and Manet's realism. He probably had seen Manet's *Mlle V . . . in the Costume of an Espada* in the Salon des Refusés the previous spring. However, Monet differs from both of these painters in his exacting observation of the specific time of day; it presages his preoccupation with the ephemeral phenomena of nature. The distinct shadow that falls across the Rue de la Bavolle points to the temporality implicit in the passing sun.

During 1864 Monet executed several paintings of the same site, including studies of high and low tide at Sainte-Adresse and views of a corner of Honfleur's port. Indeed, *Rue de la Bavolle* has a pendant by the same title in the Stadtische Kunsthalle in Mannheim. Although Monet's debt to the styles of Courbet and Manet is more than evident in this painting, his interpretation of the motif is neither imitative nor derivative. *Rue de la Bavolle* reflects Monet's originality. On July 15, 1864, Monet wrote to Bazille from Honfleur: "Ah well, dear fellow, I want to struggle, scrape, begin again, for one can do what one sees and what one understands, and it seems to me, when I see nature, that I am going to do it all, write it all out, and then have a go at it." Monet's intention to "write it all out" became the foundation for an original and personal style.

A Woman Seated Beside a Vase of Flowers

EDGAR DEGAS

Edgar Degas was born into a wealthy family on July 19, 1834. His father was the head of the French branch of a family-owned bank. After receiving a solid education at the Lycée Louis-le-Grand, Degas resolved to become a painter, pursuing a course of independent as well as institutional training. Between 1856 and 1859, Degas made two lengthy tours of Italy, studying painting. He was fascinated by the art of the Italian Renaissance, which had a profound effect upon his early development. When Degas returned to France, he devoted five years to experimenting with history painting, the most elevated genre within the hierarchy of Salon subjects. In 1862 he met Manet who probably encouraged him to adopt subjects reflecting the immediacy and, often, the ambivalence of modern life. Such a view of contemporaneity seems, at the least, quietly implicit in *A Woman Seated Beside a Vase of Flowers.*

This picture, which has been erroneously titled *Woman with Chrysanthemums*, depicts an enormous bouquet of chrysanthemums and other late-summer garden flowers, including asters, centaureas, gaillardias, and dahlias as the focal point of the composition. Next to the flowers, on the right side of the picture, a woman stares pensively out of the painting. But her gaze is directed beyond the viewer seemingly unaware of or uninterested in our presence. The identity of the woman has been debated, but there is now a consensus that she is Madame Paul Valpinçon, the wife of Degas's close childhood friend. This unusual composition seems neither a still life nor a portrait. Indeed, until recently it was believed that the figure was added to the painting after the completion of the vase of flowers. There is, however, no precedent for a pure still life such as this in Degas's work. Moreover, there is a drawing in the Fogg Art Museum (Cambridge, Massachusetts) of Madame Valpinçon that is a study for this picture and is dated 1865 by the artist.

In two essential respects, *Woman Seated Beside a Vase of Flowers* is an example of the innovative character of Degas's work. First, the explicit conventions that determined specific genres are undermined by the radical off-center composition. And second, Degas's revisions of traditional portraiture violate the expectation that the center of interest be the individual subject. In fact the distinctions between the genres themselves are here rendered ambivalent. In a notebook of 1869, Degas wrote: "Make portraits of people in familiar and typical positions, above all give their faces the same choice of expression one gives their bodies. Thus if laughter is typical of a person, make him laugh—there are, naturally, feelings that one cannot render." Degas seems to have succeeded here, however, and the enigmatic qualities of the picture have in effect been transferred to the thoughtful, reserved Madame Valpinçon.

A Woman Seated Beside a Vase of Flowers was acquired by Mrs. Havemeyer in January 1921. This work interested her since she preferred to collect the finest examples she could find by the artists with whom she was already familiar. Further, it was precisely this kind of study of personality and mood that she wanted to include in her collection.

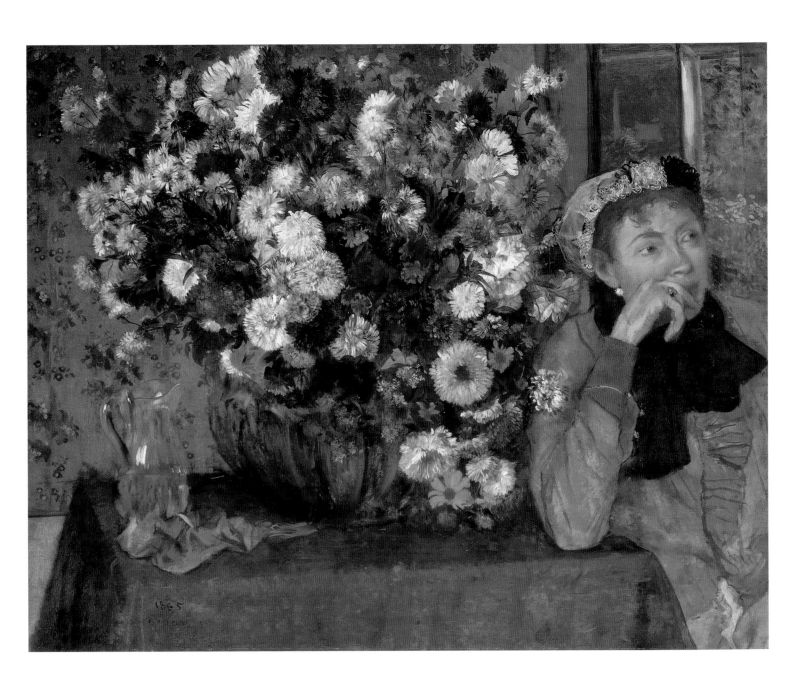

Pointe de la Hève, at Low Tide

CLAUDE MONET

This marine was one of two paintings that Monet specifically created for the Salon of 1865. Not only were both works by the unknown twenty-five-year-old painter accepted by the Salon jury they also received considerable critical praise. Later in his life, Monet maintained that these two pictures were the first works he sold (for 600 francs to the print publisher and art dealer Alfred Cadart).

Pointe de la Hève, at Low Tide.
Claude Monet.
1865.
Oil on canvas.
35 1/2 × 59 1/4 in.
(90.2 × 150.5 cm).
Kimbell Art Museum,
Fort Worth, Texas.

Although Monet had allied himself with the progressive and avant-garde artists of Paris by the mid-1860s, he nevertheless remained dependent on the Salon for the exhibition and potential sale of his art at the beginning of his career. This meant that he had to be keenly aware of the difference between a preliminary study and the finished picture appropriate for exhibition. In several of his letters to Frédéric Bazille from 1864 Monet explicitly points to this distinction. On July 15, 1864, he wrote: "On the whole, I'm quite content with my stay here [at Honfleur] although my *études* (studies) are very far from being as I should like. It really is appallingly difficult to do something which is complete in every respect, and I think most people are content with mere approximations." And on October 14, 1864, Monet wrote from Sainte-Adresse to Bazille, "It's not the *études* I'm sending you but the two *tableaux* (fully completed paintings) I'm finishing here based on my *études*."

When Monet returned to Paris from Honfleur in the fall of 1864, he continued working on the two large *tableaux* about which he had written to Bazille in October. As noted above, both this picture and its companion, *The Seine Estuary at Honfleur*, were accepted by the Salon jury. In the souvenir album of the exhibition the pseudonymous commentator Pigalle wrote that Monet was "the author of a seascape the most original and supple, the most strongly and harmoniously painted, to be exhibited in a long time. It has a somewhat dull tone, as in Courbet's [work]; but what richness and what simplicity of view!" In the *Gazette des Beaux-Arts*, Paul Mantz praised Monet for his "sensitivity to color harmony in the play of related tones, the feelings for values, the startling appearance of the whole, an audacious manner of seeing things and of commanding the observer's attention—these are the virtues which M. Monet already possesses to a high degree," and stated that he intended to "follow the future efforts of this sincere seascapist with great interest from now on."

The vivid quality of direct observation and the handling of paint that characterize Monet's out-of-doors studies, as in *Rue de la Bavolle, Honfleur* (see page 20), are replaced in the *Pointe de la Hève, at Low Tide* by a more refined and tighter execution, primarily to meet the Salon jury's expectations of the *fini* (finish) looked for in a completed *tableau*. This work derives from one of Monet's 1864 out-of-doors sketches of the Normandy coast, specifically *Horses at the Pointe de la Hève*, but it lacks the boldness and spontaneity of the preparatory study. Compared to Monet's other 1864 landscape sketches, the painting is about necessary compromise—a concession to official and public taste.

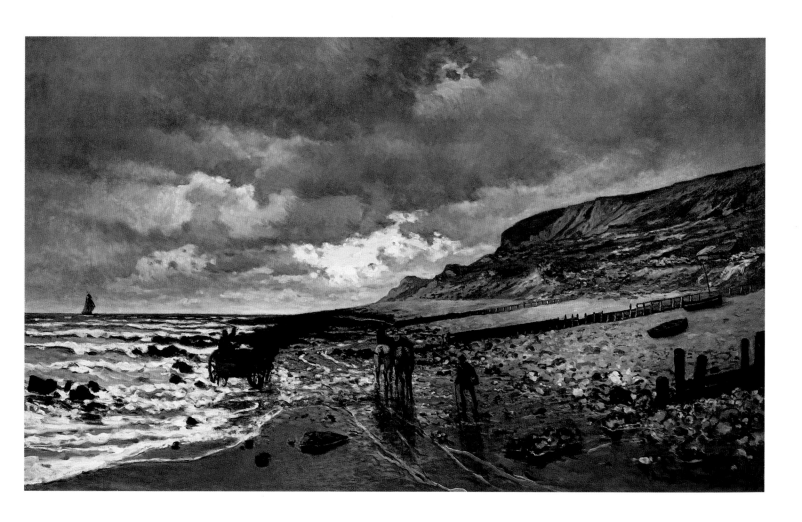

Jallais Hill, Pontoise

CAMILLE PISSARRO

The oldest of the Impressionist painters, Camille Pissarro was born on July 10, 1830, on the island of Saint Thomas in the West Indies, then a Danish colony. He was sent to France (his father had emigrated from Bordeaux), where he attended boarding school in Passy, a suburb of Paris. Pissarro returned to Saint Thomas to work in his family's shop in 1847 but had little interest in the business. In 1851 he met an itinerant Danish painter, Fritz Melbye. The following year Pissarro accompanied Melbye to Venezuela, and for the next two years he continued his self-education in art, confirming his ongoing resolve to become a painter. To that end, he traveled to Paris in 1855, enrolling at the École des Beaux-Arts; through one of his instructors he met Camille Corot, who had a decisive effect upon the formation of his art. In addition to Corot, Pissarro particularly admired Courbet and Charles-François Daubigny.

In 1859, several of Pissarro's landscapes were accepted for exhibition by the Salon jury. In that same year, while drawing from the live model at the Académie Suisse, he met Monet, who had recently arrived in Paris from Normandy. Pissarro would go on to work almost exclusively on landscapes, which had become the most "progressive" subject matter during the 1860s. Unfortunately, the range of his work from this decade will never be fully understood since at least seventy of his paintings were destroyed during the occupation of his home in 1870 by Prussian troops during the Franco-Prussian War, while he was in exile with his family in England.

Jallais Hill, Pontoise shows a curved path on a hill above the cluster of houses that forms the hamlet of L'Hermitage in the rural environs of Pontoise, a provincial capital located about twenty-seven miles northwest of Paris on the right bank of the Oise river. The deployment of broad, flat areas of color, such as in the deep greens and browns of the fields on the distant hillside, was antithetical to conventional academic technique. Moreover, Pissarro's use of a palette—or, more accurately, a paint-knife—to apply pigment intensified the rough, aggressive surface of the picture.

In spite of its progressive qualities, *Jallais Hill, Pontoise* was a tremendous success when it was exhibited, with another Pissarro landscape of the same site, at the Salon of 1868. The novelist and critic Émile Zola wrote: "This is the modern country. One feels that man has been here, digging the ground, dividing it, and creating a dejected landscape. The small valley, this heroic simplicity and candor. If it were not so great, nothing would be more banal. The temperament of the painter has drawn a precious poem of life and force out of ordinary truth."

Jallais Hill, Pontoise.
Camille Pissarro.
1867.
Oil on canvas.
34 1/4 × 45 1/4 in.
(87 × 114.9 cm).
The Metropolitan Museum of Art, New York. Bequest of William Church Osborn, 1951.

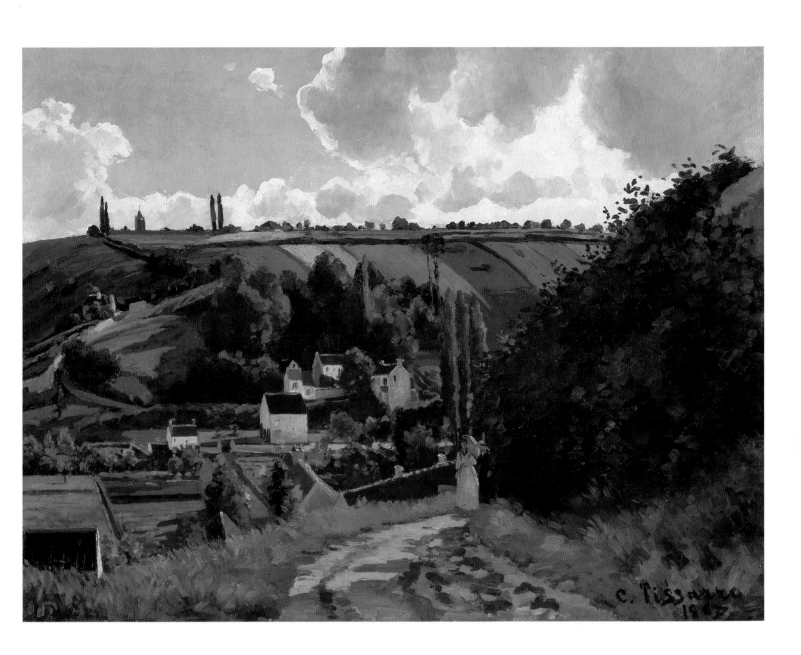

Le Pont des Arts

AUGUSTE RENOIR

Le Pont des Arts.
Auguste Renoir.
1867.
Oil on canvas.
24 1/2 × 40 1/4 in.
(62 × 103 cm).
The Norton Simon Foundation,
Pasadena, California.

Auguste Renoir was born to modest means in Limoges on February 25, 1841. In 1845 his family moved to a poor quarter of Paris, where his father worked as a tailor and his mother as a dressmaker. Renoir entered the teaching studio of Charles Gleyre in 1861. The following year he was admitted to the École des Beaux-Arts, where he was considered a mediocre student. The friendships he formed at Gleyre's studio with Monet, Sisley, and Bazille had in fact greater consequence for his art than his conventional artistic instruction. During the summer of 1862, Renoir worked in the forest of Fontainebleau—well known as a preferred locale for the Barbizon painters and as a tourist site—painting out-of-doors studies with his friends from Gleyre's studio.

At the same time, Renoir aspired to be successful at the Salon, and though his first submission to the jury of the annual exhibition was rejected in 1863, his *Esmeralda Dancing* was accepted a year later. Ultimately, Renoir disagreed with the jury about the merits of this painting, destroying it after the Salon closed. The next year Renoir was represented at the Salon by two works, but in 1866 his submission was rejected, as was his *Diana the Huntress*, now at the National Gallery of Art, Washington, D.C., in 1867.

Throughout 1867 and 1868 Renoir worked on multiple subjects. *Le Pont des Arts* is one of a limited number of cityscapes in his work. During the spring of 1867 both Monet and Renoir chose to paint panoramic views of the recently transformed French capital. Napoleon III's prefect of the Seine, Baron Haussmann, replaced the narrow streets and alleys of Paris with broad boulevards, expanded the quays, and built elaborate bridges on the Seine along with large-scale buildings as part of a vast campaign to reconstruct the city. While Monet painted from a balcony of the Louvre, Renoir worked slightly above the quay Malaquais. Not only does Renoir's vantage point represent an immediately recognizable vista of the new and modern Paris but it also features a site that resonates with officially sanctioned culture. The prominent dome on the left is the Institut de France, which housed the Académie des Beaux-Arts. The Pont des Arts, a pedestrian bridge spanning the Seine, leads to France's greatest repository of art, the Louvre. And beyond the Pont des Arts is the Pont Neuf and the two recently constructed theaters of Châtelet on the right bank.

Despite reforms to the administration, education, and display of the visual arts in 1863, Renoir and the other future Impressionists received scant support and acknowledgment under the new official arts policies. In part the reforms were intended to liberalize admission to the Salon. Nonetheless, in 1867, Renoir, Monet, Pissarro, and Cézanne were all rejected by the Salon jury. Considering Renoir's mixed success to date, his vista in *Le Pont des Arts* could not have seemed a randomly selected site but rather one that featured the high bastions—seen and unseen—of official contemporary visual culture. Painted in bright colors without regard for a subtle gradation of hues, Renoir's technique in this picture challenged the aesthetic principles fundamental to the institutions featured in *Le Ponts des Arts*.

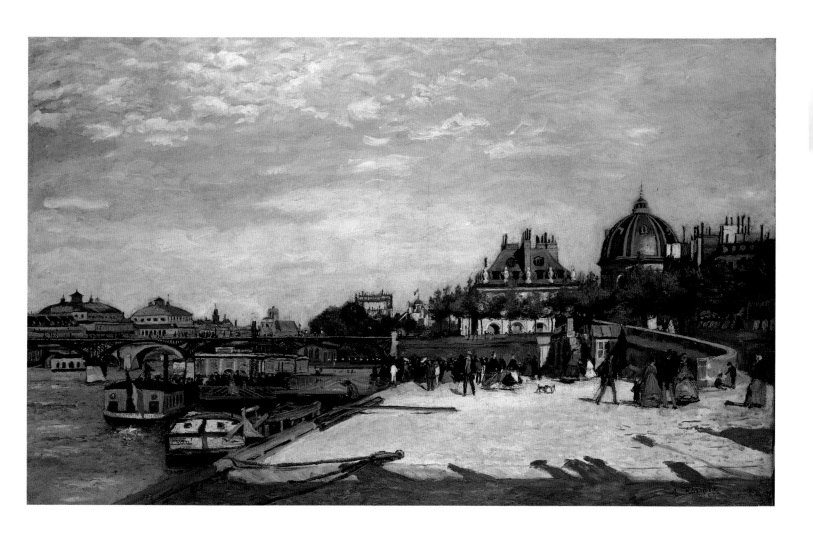

Garden at Sainte-Adresse

CLAUDE MONET

During the late 1860s, Monet sought to develop a modern style of painting while aiming to have his work accepted at the annual Salon exhibitions. These two goals ultimately came into conflict, and in the 1870s Monet would abandon his attempts to exhibit at the Salon.

Monet regularly submitted pictures to the Salon jury beginning in 1865, with initial success. His first entries, including the *Pointe de la Hève, at Low Tide*, were exhibited that year and received their share of praise. In 1866 two paintings were again accepted, and his *Woman in a Green Dress*, now in the Kunsthalle at Bremen, was singled out by the critics, including the writer Émile Zola. Monet completed and submitted a large-scale painting, *Women in the Garden*, with another picture to the Salon jury of 1867. Both works were rejected. The pattern of Monet's Salon efforts, however, makes clear that he was committed to the creation of landscapes and figure paintings with explicitly contemporary themes in a modern style.

Garden at Sainte-Adresse exemplifies Monet's interest in the look of modern life—*la vie moderne*. The picture was carefully planned and executed: it exudes ambition. What Monet originally intended for the brilliantly innovative *Garden at Sainte-Adresse* is unclear. Apparently, he did not submit it to the Salon jury of 1868. However, Monet no doubt realized the importance of the picture: it is believed that he borrowed the painting from Victor Frat's collection and included it in the fourth Impressionist group exhibition in 1879.

For financial reasons, Monet had moved to the home of his cousins in Sainte-Adresse during the summer of 1867. The setting of the picture is a seaside garden, presumably attached to a comfortable villa, with a view of the busy harbor of Honfleur in the distance. The four well-dressed figures in the garden are sometimes identified as members of Monet's family and the locale as that of his cousin's home. The picture shows upper-class leisure, with the figures casually disposed throughout the carefully maintained garden. While the man and woman in the distance appear engaged in conversation, the people in the foreground watch the crowded sea on which pleasure and commercial crafts mingle. The rewards of French economic expansion—notice the tricolor on the right flag pole—during the 1860s are vividly displayed: this work is an icon of modern bourgeois life.

Monet referred to *Garden at Sainte-Adresse* as "my Chinese painting where there are some flags." Monet and his contemporaries, caught up in the vogue for things Asian, often conflated Japan and China. The compressed pictorial space and unusual vantage point in *Garden at Sainte-Adresse* are similar to the formal characteristics of Japanese wood-blocks. The composition was probably derived from a specific Japanese print by Katsushika Hokusai, *Fuji Viewed from the Sazaido*, a copy of which Monet owned. The horizontal bands that organize the composition appear to imitate Hokusai's composition. Moreover, the use of broad areas of unmodulated color, often seen in Japanese prints, was perhaps a source of inspiration for the intensity of Monet's own palette, which boldly deploys saturated colors produced by pure pigments, such as the sharply contrasting reds and greens in the foreground.

Garden at Sainte-Adresse.
Claude Monet.
1867.
Oil on canvas.
38 ⅜ × 51 ⅛ in.
(98.1 × 129.9 cm).
The Metropolitan Museum of Art, New York. Purchased with special contributions and purchase funds given or bequeathed by friends of the Museum, 1967.

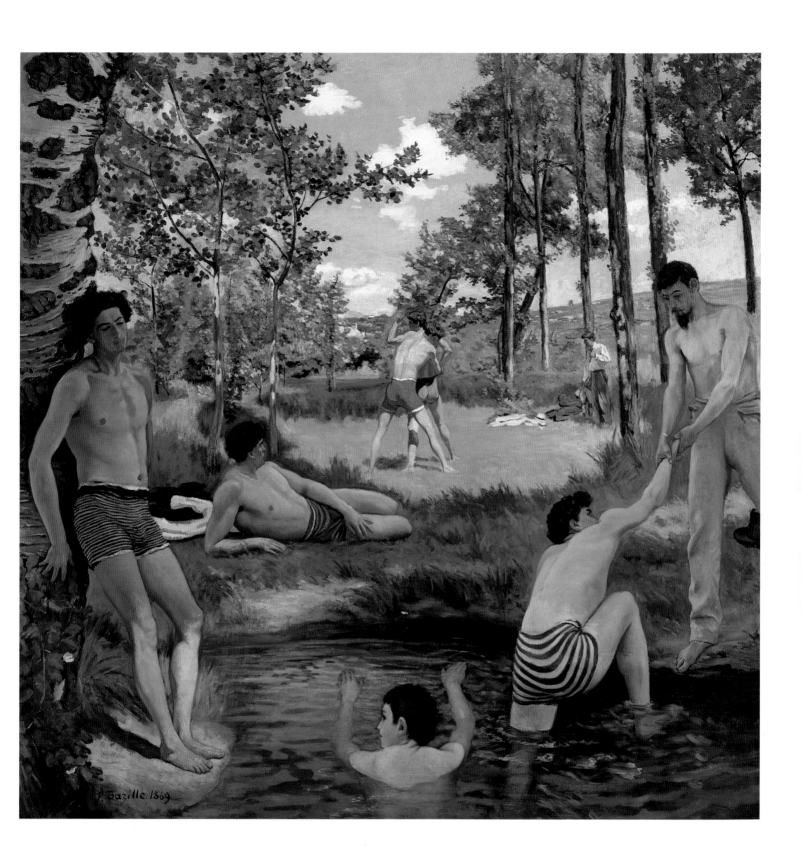

At the Races in the Countryside

EDGAR DEGAS

*A*t the Races in the Countryside is a small but radical representation of bourgeois recreation during the Second Empire (1851–70). Its asymmetrical composition, with the carriage cropped at the bottom edge of the painting, typifies Degas's efforts to represent contemporary subjects in a style that is itself distinctly innovative. Degas avoids a conventional perspective, in which the principal figures of a composition are placed in its center, not truncated at the painting's edge. The organization of Degas's design suggests a quick and partial glance, thought to be a more accurate depiction of the actual experience of vision. As the writer and critic Edmond Duranty declared in a 1876 pamphlet *The New Painting*, "In an age like ours, when there seems nothing left to discover, when previous ages have been analyzed so much, and when we suffocate under the weight of the creations of past centuries, it is a great surprise to see ideas and original creations suddenly burst forth." Duranty stressed the importance to the artist of themes that "accurately express the everyday life of a country." Not surprisingly, Degas and Duranty were friends.

The date of this picture and the identities of its figures have been debated. It is now generally believed that the subjects are Paul Valpinçon — Degas's childhood friend — and his family, including his wife, son, a professional wet nurse, and the family bulldog. The identification of the subjects and the locale, the races at Argentan near the Valpinçons' home at Ménil-Hubert in Normandy, make more precise dating possible: the summer of 1869.

At the Races in the Countryside has been characterized as both a group portrait and a scene of modern daily life or genre painting. This radical picture, however, is not related to the conventions of either contemporary portraiture or genre painting. It also has been suggested that the emphasis on the division of earth and sky makes the picture an Impressionist landscape. Whatever the case, throughout the 1860s and 1870s, Degas subverted the standard conventions and expectations for painting, particularly assumptions about distinct traditional categories of subject matter. Degas's respect for academic training, principally drawing, remains evident in his art. Yet the precise observation and detail in *At the Races*, achieved by careful drawing, is at odds with the apparent transience of the subject established by the innovative composition.

Degas continued to be particularly interested in this picture even after its completion. During a visit to New Orleans in 1872, he wrote to his friend, the painter Jacques-Joseph Tissot: "And the [picture] of the family at the races, what is happening to that?" Paul Durand-Ruel, a dealer, had purchased the painting in September 1872 and sent it to London, where it was shown at the fifth exhibition of the Society of French Artists. In April 1873 *At the Races* was acquired by the opera singer Jean-Baptiste Faure. Degas borrowed the work back from Faure for the first Impressionist exhibition of 1874. Only one critic, Ernest Chesneau, commented on the picture, favorably, in the reviews of this historic exhibition. Unlike the other participants, particularly Monet, Degas remained disdainful of the term "impressionist," preferring to describe his work as "realist" or "independent."

*At the Races in the Countryside.
Edgar Degas.
1869.
Oil on canvas.
14 ⅜ × 22 in.
(36.5 × 55.9 cm).
Museum of Fine Arts, Boston.
1931 Purchase Fund.*

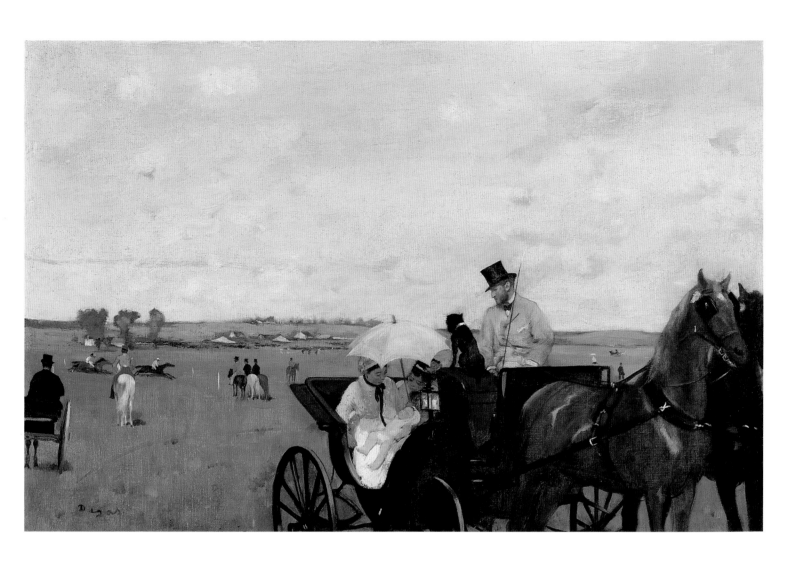

Young Woman with Peonies

FRÉDÉRIC BAZILLE

*D*uring the mid-1860s Bazille worked closely with Monet and Renoir. By the end of the decade, however, Bazille seems to have developed a new and deeper appreciation of Manet. In March 1870 Bazille asked Manet to pose for him in his new studio on the rue La Condamine. In December 1870 he wrote to his father: "I've amused myself till now painting the interior of my studio with my friends. Manet did me in it, I'll send it to the Montpellier exhibition." In keeping with their friendship, Manet did indeed paint the figure of Bazille in Bazille's painting, standing at his easel amid the others. While Monet and Renoir continued to experiment with *plein-air* painting, Bazille seems to have preferred to work in his studio, as did Manet.

Young Woman with Peonies is one of two versions of this subject executed by Bazille during the spring of 1870; both versions were executed in his Paris studio. The identity of the woman is unknown but apparently she also posed for Bazille's *The Toilette*, now at Musée Fabre, Montpellier, the same year. *The Toilette* was also conceived of and executed in the studio and is an eclectic mix of sources similar to Manet's quotation and transformation of divergent references. Bazille, of course, knew Manet's 1863 *Olympia*, now at Musée d'Orsay, in which a black servant presents a bouquet of flowers to a reclining nude. *Olympia* played a part in Bazille's *Young Woman with Peonies*, but it was a minor one. On the other hand, Bazille's use of sharp contrasts of light and dark, a favorite device of Manet's, is discernible in the picture's construction. And the model has the same detached presence typical of Manet's figures. Her haunting gaze is indifferent to the viewer.

Bazille's use of an African model is indicative of the fascination with the "exotic" that developed in France during the nineteenth century. Ethnic identities beyond the borders of Europe came to be considered exotic—extraordinary, strange, and unaccustomed—rather than foreign. French nineteenth-century culture, including painting, upheld a mistaken belief in ethnic superiority. More often than not, non-European races were cast as romanticized primitives. Bazille greatly admired the work of Eugène Delacroix, who frequently included Africans in his so-called Orientalist (non-Western) paintings, such as the *Death of Sardanapalus,* in which violence and sensuality are acceptable if located in the exotic. Although today notions of ethnic inferiority are offensive, in the nineteenth century such ideas were politically and culturally expedient. Bazille's rendering of a black woman as a servant simply represents the reality of ethnic difference in nineteenth-century Paris.

Young Woman with Peonies.
Frédéric Bazille.
1870.
Oil on canvas.
23 ⅝ × 29 ⅛ in.
(60 × 74 cm).
The National Gallery of Art,
Washington, D.C. Collection
of Mr. and Mrs. Paul Mellon.

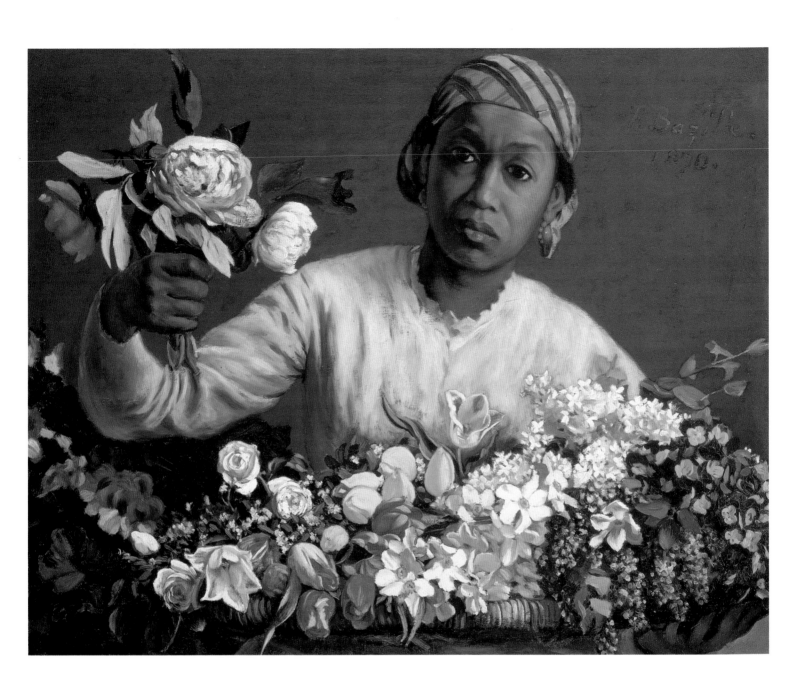

View of Paris from the Trocadéro

BERTHE MORISOT

Berthe Morisot was born in Bourges on January 14, 1841. Her father was a government official who held posts in Caen and Rennes before moving to Paris. Together with her sisters, she took drawing lessons from the academic painter Geoffrey Chocarne, and then Joseph-Benoît Guichard. Guichard introduced the nineteen-year-old to Camille Corot, with whom she worked at Ville-d'Avray during the summer of 1861. Morisot's parents supported her artistic ambitions, building a studio for her and her sisters in the garden of their home. In 1864 she first exhibited at the Salon. During the late 1860s Morisot became acquainted with Henri Fantin-Latour, Degas, and Manet, and in 1874 she married Eugène Manet, brother of the painter Edouard. Morisot played a significant role in the formation and promotion of Impressionism, participating in all but one of the eight Impressionist group exhibitions.

View of Paris from the Trocadéro.
Berthe Morisot.
1872.
Oil on canvas.
18 × 32 in.
(45.8 × 81.4 cm).
The Santa Barbara Museum of Art, Santa Barbara, California. Gift of Mrs. Hugh N. Kirkland.

The hazy atmospheric quality of *View of Paris from the Trocadéro* can be related to Corot, and the choice and treatment of its subject to an earlier painting by Manet, *The Exposition Universelle of 1867*, now in the Nasjonalgalleriet in Oslo. Yet Morisot's technique and composition are very much her own. Panoramic views of Paris had been painted throughout the nineteenth century, and typically, treatments of this subject emphasized the familiar buildings, bridges, or monuments of the French capital in deep, illusionistic space. Since the Renaissance, the use of perspective had enabled painters to create the illusion of representing three-dimensional space on a two-dimensional surface, the flat canvas. In other words, an image would appear to be a transparent window onto the world. Morisot's daring composition, however, eschews traditional perspective. For instance, the path across the bottom of the picture thwarts a consistent spatial illusion. The two women, identified as Morisot's sisters, Edma Pontillon and Yves Gobillard, look outside of the picture rather than at the panoramic view. Cleverly, Morisot has placed a child, probably Gobillard's daughter Paule, on the path with her back turned to the viewer. The child gazing toward the distant skyline of Paris—including, from left to right, the two church towers of Sainte-Clotilde, Notre-Dame, and Saint-Sulpice, the domes of Les Invalides, and beyond it the Panthéon—by itself suggests deep space.

There is another unusual feature to Morisot's work. Ordinarily, figures in the foreground of a painting would be more fully resolved or in focus than other elements of the picture. And the figures' facial expressions were often exploited to create or accentuate specific emotional states. But Morisot rejected the conventional sentimentality often observed in the facial expressions of Salon pictures. The faces of Morisot's sisters are simply dabs of pigment, thereby preventing any reading at all of their states of mind. They do not communicate either with each other or with the viewer. By rendering these figures with the same cursory notations of paint, Morisot has called into question a fundamental tenet of conventional representation. As charming as the painting appears to us today, during the early 1870s Morisot's *View of Paris* was a radical departure from the picturesque vista in favor of a cityscape closer to her experience of modern urban life.

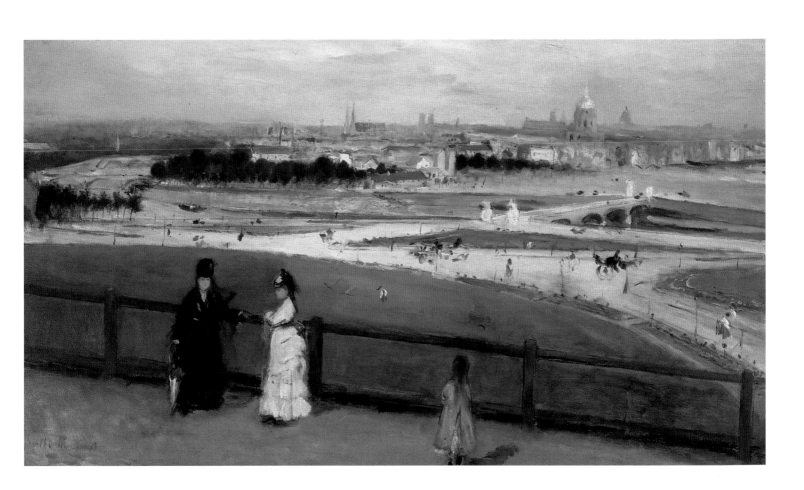

The Bridge at Villeneuve-la-Garenne

ALFRED SISLEY

The Bridge at Villeneuve-la-Garenne.
Alfred Sisley.
1872.
Oil on canvas.
19 3/4 × 25 5/8 in.
(49.5 × 65.4 cm).
The Metropolitan Museum of Art, New York.

Born of wealthy British parents on October 30, 1859, Alfred Sisley was raised in France but was sent to London to prepare for a career in commerce in 1857. By the time he returned to France in 1862, he had decided to become an artist. At the age of twenty-three, Sisley entered the private teaching studio of Charles Gleyre and enrolled at the École des Beaux-Arts. At Gleyre's studio he met and befriended Renoir, Bazille, and Monet. With Renoir and Bazille, Sisley explored the forest of Fontainebleau, painting out-of-doors between 1862 and 1865. As a result of the Franco-Prussian War of 1870, Sisley's father's business collapsed and thereafter his life was to be a constant struggle with poverty. During the post-war years of 1872 through 1874, Sisley developed his mature style and a relatively restricted range of landscape themes that remained little changed throughout the rest of his life.

During the early 1870s Sisley, Monet, Pissarro, and Renoir lived near each other in various towns such as Louveciennes, Port Marly, Argenteuil, Bougival, and Villeneuve-la-Garenne, which is the setting of this picture. Between 1872 and 1874, these painters—the future Impressionists—shared related interests and goals. In particular, they had a strong commitment to working out-of-doors (*plein-air* or open-air painting), thereby reproducing in their landscapes the effects of light and atmosphere as convincingly as possible. Although less experimental in his style than Monet or Pissarro, and less varied in his subject matter, Sisley nevertheless rendered these effects with a subtlety and nuance worthy of comparison with the work of his painter friends. Throughout his career, Sisley limited himself to landscapes almost exclusively. He typically used rivers and roads to provide the structure for his compositions. Thus *The Bridge at Villeneuve-la-Garenne* is relatively atypical of Sisley's landscapes with only the boldly cropped bridge suggesting illusionist space.

Rather than select a picturesque view of Villeneuve-la-Garenne, Sisley presents an innovative composition featuring the cast-iron and stone suspension bridge that provided a road link between Gennevilliers and Saint-Denis to Paris. During the 1860s and 1870s, barges, steam passenger boats, yachts, and rowboats crowded the Seine. This constant traffic on the river is absent from Sisley's picture, although we do see beached rowboats on the river's bank and one boat with three passengers on the Seine itself. Sisley has chosen to emphasize the bridge, built in 1844, as a sign of modernity along the Seine.

The paint surface is thin in various passages of the work, allowing the light-toned priming of the canvas to show through; it thus contributes to the overall tonality, particularly in the river. Other passages of the picture are densely painted resulting in areas of textured impasto. Executed on the site, *The Bridge at Villeneuve-la-Garenne* has the feel of direct observation. Yet different touches of color apparently have been applied over a dried layer of paint suggesting either refinements in the studio or subsequent sessions "before the motif." The tonality of the picture is unusually bright for Sisley. He was undoubtedly aware of Monet's treatments of the railroad and foot bridges at Argenteuil, a short distance upstream from Paris.

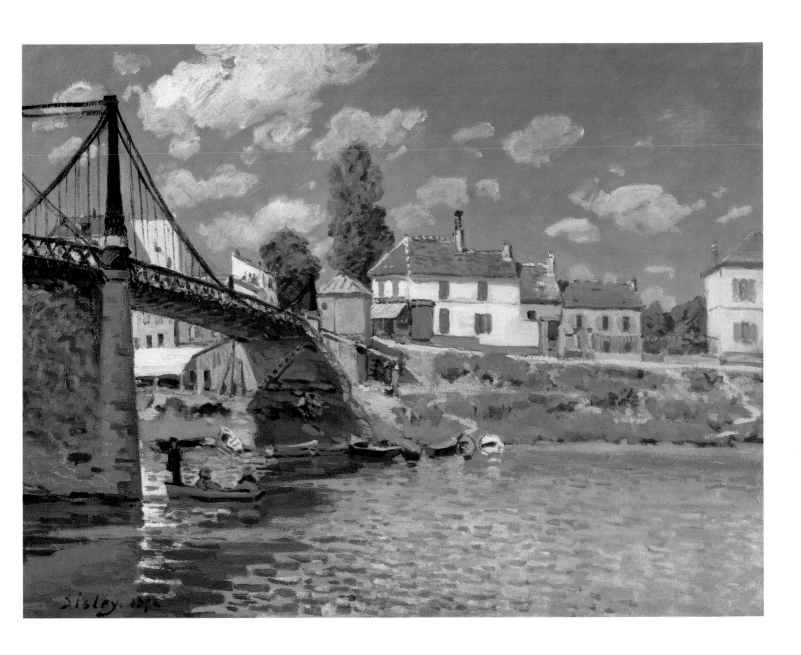

The River Oise, near Pontoise

CAMILLE PISSARRO

*I*n 1866 Camille Pissarro and his family moved to Pontoise, a small town about eighteen miles northeast of Paris. He worked in and around Pontoise through 1883, which, along with its environs, particularly the village of L'Hermitage, became the principal source of the artist's motifs. Located on a series of hills above the river Oise, Pontoise was reshaped by rural modernization during the economic development of the Second Empire and Third Republic. The town was far enough from Paris to retain its own identity during the early nineteenth century, yet close enough to engage in trade. Three years before Pissarro's arrival there, the French railway system constructed an iron bridge across the Oise, linking Pontoise with the French capital. This event transformed the town and the area surrounding it. Subsistence farming began to be replaced by a market economy. Signs of industrialization, modernization, and a changing class structure—factory chimneys, new gaslights along rural streets, and fashionably dressed women and children strolling in agrarian settings—make up much of Pissarro's imagery.

Throughout his years in Pontoise, the artist worked to subvert the conventions of the picturesque, or classical, landscape. Even the titles of his paintings were often calculated to call into question the old expectations of the genre. They are notable for their precision and references to modernity. The rather neutral title of this picture is an exception.

Originality was among the principal concerns of the Impressionists; thus, one appeal of Pontoise for Pissarro may have been its lack of distinct association with any earlier painter of merit, which allowed him to develop its image unfettered by a prior tradition. Despite this highly individual relationship between the painter and his site, his early work at Pontoise is nonetheless indebted to the examples of Corot, Daubigny, and Courbet. By 1873 Pissarro had begun a period of intense stylistic experimentation, which amounted to a revision of his earlier naturalist or realist (see *Jallais Hill, Pontoise*, page 26) style. This picture masterfully exemplifies Pissarro's handling of the transient, or fugitive, qualities so strongly associated with Impressionism and open-air painting. *The River Oise, near Pontoise* appears to have been executed out-of-doors. Its surface is painterly but contains little of the fluid and calligraphic brushwork employed by Monet or Sisley at the same time. In 1873 Théodore Duret wrote to Pissarro: "You haven't Sisley's decorative feeling nor Monet's fanciful eye, but you have what they have not, an intimate and profound feeling for nature and the power of the brush, with the result that a beautiful picture by you is something absolutely definitive. . . . Don't think of Monet or Sisley, don't pay attention to what they are doing, go on your own, your path of rural nature. You'll be going along a new road, as far and as high as any master!"

The River Oise, near Pontoise.
Camille Pissarro.
1873.
Oil on canvas.
18 × 21 3/4 in.
(45.3 × 55 cm).
The Sterling and Francine Clark Art Institute, Williamstown, Massachusetts.

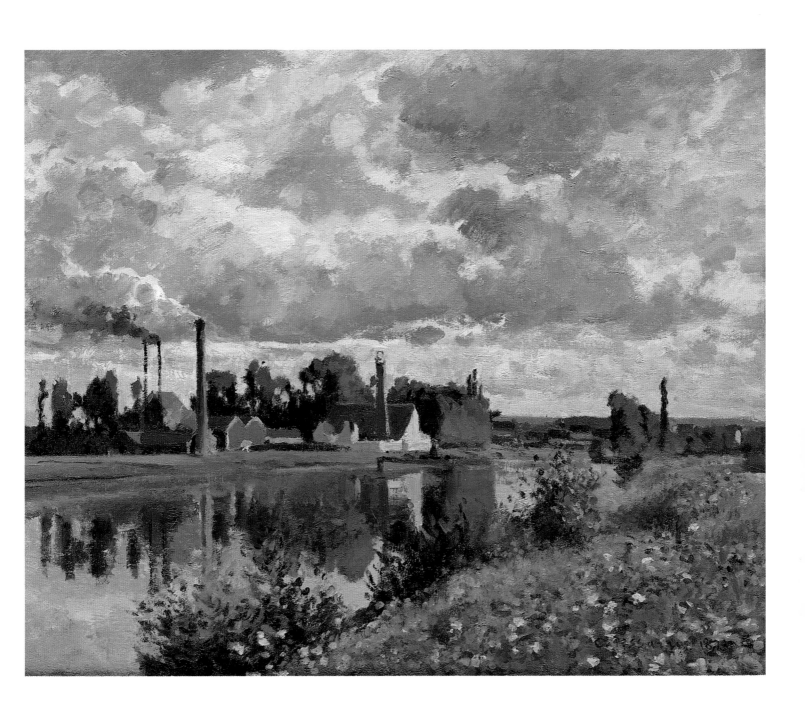

House of Père Lacroix

PAUL CÉZANNE

*P*aul Cézanne, born on January 19, 1838, in Aix-en-Provence, began life comfortably enough as the son of a prosperous manufacturer who later became part owner of the local bank. He received a solid classical education in Aix, where he formed a close friendship with his classmate Émile Zola, the future novelist and critic. Obeying his father, Cézanne enrolled in the University of Aix as a law student. He was determined, however, to become a painter. In 1861 he was finally granted permission by his father to study painting in Paris. There he attended the Académie Suisse where he made drawings from the live model. His early work is characterized by violent and erotic subject matter, a dark palette, and a rough application of pigment. In 1862 Cézanne apparently failed the entrance examination to the École des Beaux-Arts. He exhibited at the Salon des Refusés the following year. Between 1864 and 1869, all of Cézanne's submissions to the annual Salon were rejected.

In 1872 Cézanne, his future wife, Hortense Fiquet, and their infant son moved to Pontoise. Toward the end of that year, the Cézanne family moved again to Auvers-sur-Oise, near Pontoise, remaining there through the beginning of 1874. Following a self-imposed apprenticeship with Pissarro at Pontoise and Auvers, Cézanne devoted himself to out-of-doors painting, lightening his palette. Landscape had not figured prominently in Cézanne's work of the 1860s but it was to become one of his most favored motifs, second only in quantity produced to the genre of bather subjects. *House of Père Lacroix* is one of the numerous landscapes that Cézanne painted during his close working relationship with Pissarro.

The setting of this picture is a hillside at Auvers, featuring the house of "father" Lacroix. (Van Gogh would later paint the same house but from a different vantage point in a work now in the Toledo Museum of Art, Toledo, Ohio.) This radiant painting appears to have been executed in the open air in a variety of spontaneous and flickering brush strokes depicting the quality of bright light quivering through dense foliage. Typically, Cézanne incorporated architecture into his landscapes to provide order and structure. Placing Père Lacroix's house, painted in a variety of white chalky hues and a muted red for part of the roof, in the center of the composition, Cézanne created not only a focal element, but also a palpable physical component in the picture. In turn, the dense green foliage is treated in a remarkably bold and loose manner. The abbreviated and highly personal touch of the artist becomes part of the painting's subject and meaning. Various shades of green combined with yellow and white capture the nuances of color and light that convey the freshness of a spring or summer morning.

Among the most confident and fully resolved of Cézanne's work from this period, it is likely that this picture was included with the two other paintings by the artist in the first Impressionist group exhibition of 1874. Supporting the claim that the *House of Père Lacroix* was exhibited in this show (which has been debated) is the artist's signature and the date in the lower left corner of the picture. Cézanne signed only about sixty of his nearly one thousand extant works.

House of Père Lacroix.
Paul Cézanne.
1873.
Oil on canvas.
24 1/8 × 20 in.
(61.3 × 50.6 cm).
The National Gallery of Art,
Washington, D.C.
The Chester Dale Collection.

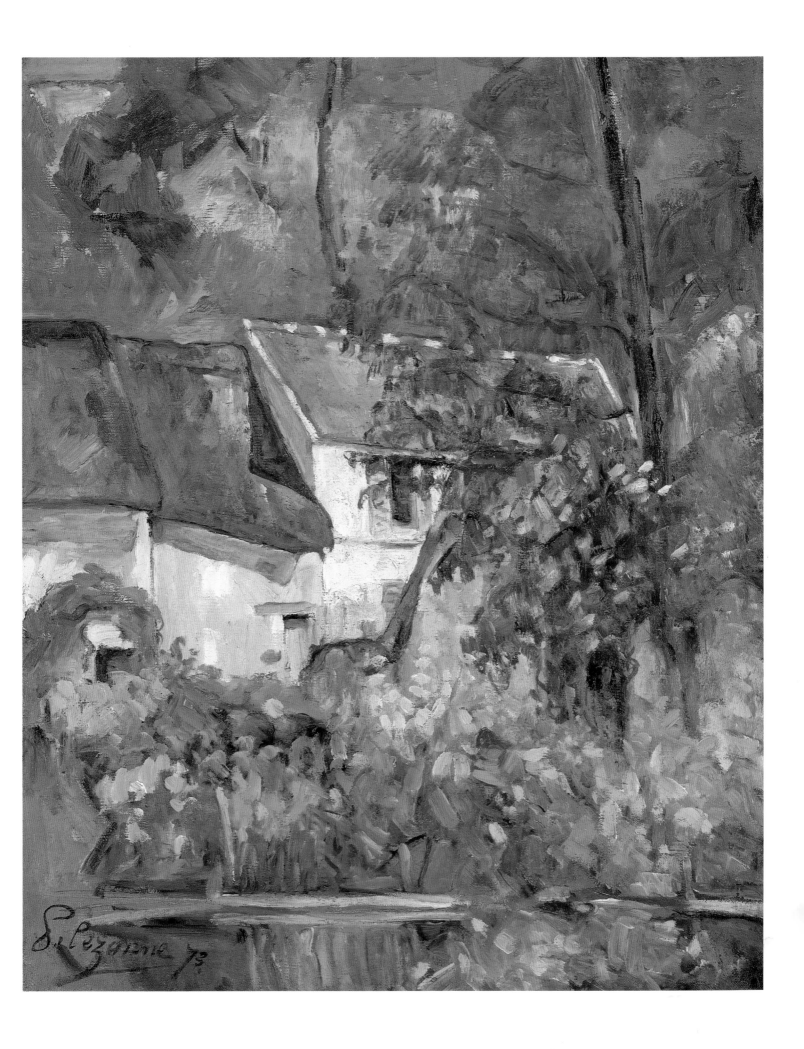

Monet Painting in His Garden at Argenteuil

AUGUSTE RENOIR

onet, Bazille, Renoir, and Sisley—friends since meeting at the teaching studio of Charles Gleyre—painted several portraits of each other throughout the late 1860s. Unlike this picture, the portraits from the 1860s are set in interiors, mostly artists' studios. During the summers of 1872 and 1873, Renoir repeatedly visited the Monet household in Argenteuil, painting side by side with his friend. And it was here that Renoir found the setting for this picture, the garden of the first house leased by Monet, the so-called Maison Aubry at the corner of the rue Pierre-Guienne and the boulevard Saint-Denis. Monet's renderings of his gardens at Argenteuil typically show them as private, self-contained spaces; Renoir, however, includes the dense cluster of recently built houses surrounding the Monets' home in this suburb of Paris.

Renoir's *Monet Painting in His Garden at Argenteuil* exemplifies the aesthetic of working directly from nature—out-of-doors—which united the future Impressionists (not yet so named) during the early 1870s. This was not pristine nature but rather a landscape that showed signs of its contemporary transformation. Wearing his round beret and a blue jacket, Monet is shown preoccupied with his canvas rather than the viewer; he is a part of the landscape rather than the distinct focus of the composition. Renoir's picture is thus both a portrait and a landscape. And the details emphasize the theme of painting directly from the motif. Monet's easel is a portable one that facilitates *plein-air* painting. Beneath the easel is a *boîte de campagne*, a complete outdoor painting kit.

The painting Monet is working on has sometimes been identified as a picture in the National Gallery in Washington, D.C., but the angle from which this work was painted is inconsistent with Monet's position in Renoir's depiction. Nevertheless, the two pictures, Renoir's and the work of Monet's in Washington, are stylistically related. The soft brushing of the hedge of dahlias with touches of red, yellow, and white flowers is similar in both Renoir's and Monet's work. Renoir's facture—the manner in which the painting is physically made—is both variegated and loose. The remarkable display of dabs and dashes of pigment is typical of rapidly rendered pictures executed out-of-doors.

Renoir's picture, incidentally, is painted over an earlier work. It has been suggested that the underlying painting might be a discarded canvas of Monet's, one that he provided for his friend during a visit. Given the subject of the painting, this seems remarkably appropriate.

Monet Painting in His Garden was purchased by Paul Durand-Ruel for 800 francs at auction on April 17, 1896. It appeared on the market again in 1902. Durand-Ruel purchased it again but this time for 4,700 francs. By the turn of the century, Impressionist pictures were rapidly escalating in value.

Monet Painting in His Garden at Argenteuil.
Auguste Renoir.
1873.
Oil on canvas.
18 × 23 ½ in.
(46 × 60 cm).
Wadsworth Atheneum, Hartford. Bequest of Anne Parrish Titzell, 1957.

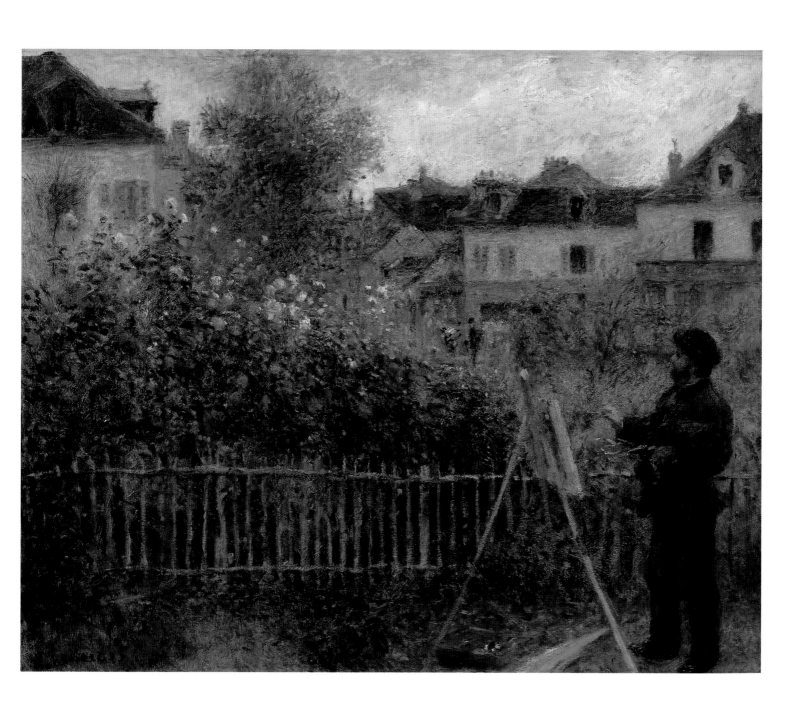

Boulevard des Capucines

CLAUDE MONET

After years of poverty and Salon rejections, Monet's circumstances improved considerably during the early 1870s. The rapid economic recovery that followed the Franco-Prussian War had a stimulating influence on the art market. Monet's sales to a growing number of private collectors and to the dealer Paul Durand-Ruel enabled the artist to establish a comfortable household with a garden in the Paris suburb of Argenteuil. Nevertheless, Monet hoped to increase sales further and add to his commercial visibility by establishing an "artistic corporation" (Société Anonyme) that would give artists opportunities to exhibit away from the annual Salon. Working with Pissarro and Renoir, Monet and others brought about the first exhibition of the Société Anonyme, which opened on April 15, 1874. The show was held at 35, boulevard des Capucines in the former studio of the photographer Gaspard-Félix Tournachon, known as Nadar. It was on the occasion of this show that a critic, using the word "impressionist" sarcastically, inadvertently named a new style of art.

This picture was painted from the window of Nadar's studio in 1873. Monet selected a view of Paris that showed the city in its most modern transformation. The broad boulevard leading to the recently completed Place de l'Opéra was one element of Baron Haussmann's plan to reshape the capital. Once completed, the boulevard des Capucines became one of the busiest and most fashionable streets in the city center. Monet, quick to appreciate the vitality of it all, became deeply engaged with the idea of modernity—his goal, to render the constant flux and anonymity of contemporary urban experience.

As in the *Garden at Sainte-Adresse* (see page 30), Monet uses an elevated vantage point to structure his composition. The fluid brushwork suggests he worked with great speed to convey the bustling quality of the street below Nadar's studio. Although a muted palette conveys the effect of an overcast day, the picture is enlivened in its design by the crowd which moves along the street. Of this work, shown in the first Impressionist group exhibition in 1874, the critic Ernest Chesneau wrote: "The extraordinary animation of the public street, the crowd swarming on the sidewalks, the carriages on the pavement, and the boulevard's trees waving in the soft light—never has movement's elusive, fugitive, and instantaneous quality been captured and fixed in all its tremendous fluidity as it has in this extraordinary, marvelous sketch (*esquisse*) that Monet has listed as *Boulevard des Capucines*." Chesneau refers to the picture as a "sketch" rather than as a *tableau*, or fully completed painting. Other critics failed to share in Chesneau's enthusiasm. Louis Leroy, for example, asked, "Tell me what those innumerable black tongue-lickings in the lower part of the picture represent." The champion of Courbet and Realism, Jules-Antoine Castagnary wrote: "Monet has frenzied hands that work marvels. But to tell the truth, I never could find the correct optical point from which to look at his *Boulevard des Capucines*. I think I would have had to cross the street and look at the picture through the windows of the house opposite."

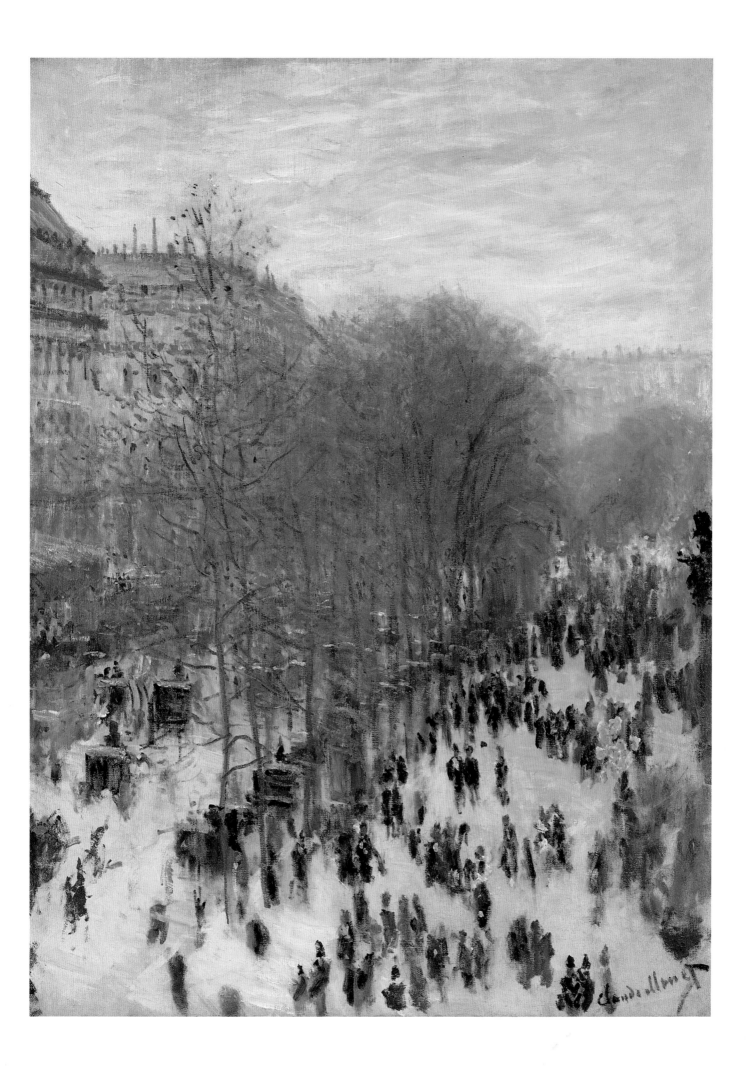

Boating

EDOUARD MANET

oating was painted at Argenteuil while Manet was staying at Gennevilliers, a family home, during the summer of 1874. The models are Rodolophe Leenhoff, the painter's brother-in-law, and an unidentified woman. Apparently, Manet had wanted to use Monet and his wife, Camille, as the models for a large-scale figure painting. Monet, however, was not an ideal model since he was reluctant to remain idle for any great length of time.

Boating is often considered an Impressionist painting, and Manet—very much a man of the modern city—did paint out-of-doors with Monet and Renoir during this summer. Unlike Monet, however, Manet used figures rather than landscape as the basis for his depictions of contemporary experience. Manet's placement of the figures in his design, which causes them to come forward toward the picture plane, and the cropping of the boat are as innovative as any elements found in other Impressionist compositions. But Manet did not use the broken brushwork and vivid palette that were typical of Monet's and Renoir's painting during the early 1870s, nor was he particularly interested in rendering fleeting atmospheric conditions. For instance, despite the intensity of its color, the Seine in the background of *Boating* does not shimmer with the reflections of light as it might in the hands of the other artists. For Monet and the other Impressionists during this period figures tend to dissolve into the landscape that surrounds them. By contrast, Manet continued to imbue his figures with distinct corporeal presence; they have volume and mass on the flat surface of the canvas.

Despite Manet's friendships with the Impressionists and the affinities that exist between their work, he refused to participate in any of the group exhibitions or auctions they organized. He preferred instead to display his work at the annual Salon exhibitions, small-scale gallery shows, or viewings in his studio. During the summer of 1874, Manet executed a second large-scale figure painting entitled *Argenteuil*, now at the Musée des Beaux-Arts, Tournai, which he successfully exhibited at the Salon of 1875. He included *Boating* in his studio exhibition of 1876 and exhibited the painting in the Salon of 1879.

Although Manet would not exhibit with the Impressionists, his relationship with the group was frequently noted. According to Stéphane Mallarmé: "Manet and his school use simple colour, fresh, or lightly laid on, and their results appear to have been attained at the first stroke, that ever-present light blends with and vivifies all things." He continues, claiming that "MM. Claude Monet, Sisley, and Pizzaro [*sic*] paint wondrously alike; indeed a rather superficial observer at a pure and simple exhibition of Impressionism would take all their works to be those of one man, and that man, Manet."

The Havemeyers' and other collectors' enormous enthusiasm for Manet's work was responsible for the extraordinary number of Manet paintings in American museums today, particularly The Metropolitan Museum of Art in New York.

Boating.
Edouard Manet.
1874.
Oil on canvas.
38 1/4 × 51 1/4 in.
(97.1 × 130.2 cm).
The Metropolitan Museum of Art, New York. The H.O. Havemeyer Collection, 1929.

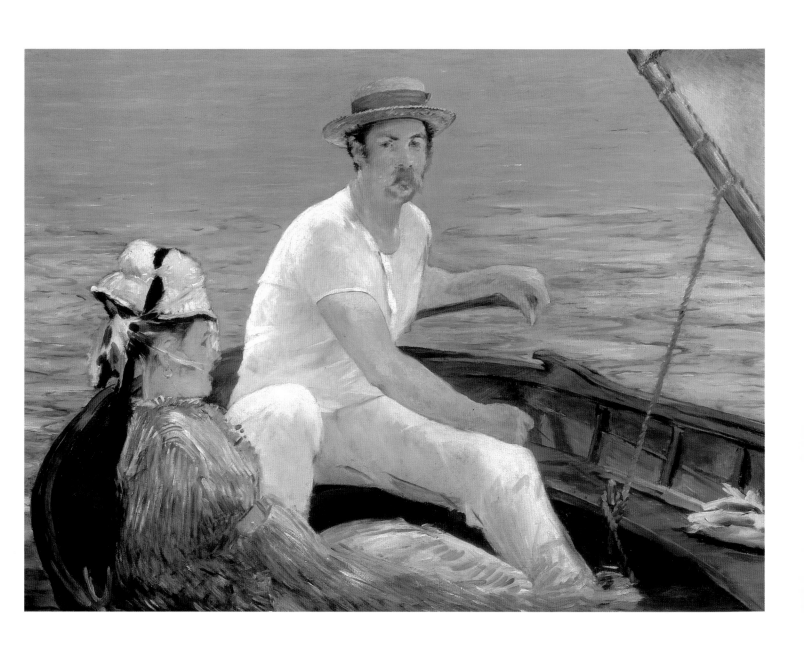

Hanging the Laundry Out to Dry

BERTHE MORISOT

This painting was exhibited by Morisot with sixteen of her other works in the second Impressionist group exhibition of 1876. In *La Chronique des Arts et de la Curiosité*, a contemporary journal, Alfred de Lostalot lamented: "Given her delicate color and the adroitly daring play of her brush with light, it is a real pity to see this artist give up her work when it is only barely sketched because she is so easily satisfied with it." Arthur Baignières's review of the exhibition in *L'Echo Universel* was similarly critical of Morisot: "She pushes the system to its extreme, and we feel all the more sorry about this as she has rare talent as a colorist." Charles Bigot's review in *La Revue Politique et Littéraire* echoed the same criticisms: "Berthe Morizot [*sic*] was born with a real painter's talent. It would take very little for her color to really please. You could say that she particularly is the victim of the system of painting that she has adopted." The conservative critic Albert Wolff, however, failed to see any merit in Morisot's work: "Her feminine grace lives amid the excesses of a frenzied mind." Still, Morisot was treated less harshly than the other participants in the exhibition.

It is clear that what the artist took to be a completed work the critics considered unfinished. The spontaneity and boldness of Morisot's brushwork in *Hanging the Laundry Out to Dry* is extraordinary and deliberately daring. Since the picture is signed it is reasonable to conclude that Morisot believed her goal accomplished. She does not list it as a study in the catalogue. Thus the present picture was intended, at least in part, as a polemic against the smooth and polished surfaces of academic painting. The same vigorous and abbreviated brushwork is used to render both the figures and the other elements of the composition—a fusion of figure and context seen in other Impressionist *plein-air* works. Morisot has applied the paint in a "wet-into-wet" manner (fresh paint brushed into a surface not yet dry); touches of color such as the dashes of red and blue enliven the surface.

Equally as radical as Morisot's execution is her choice of subject matter: ordinary women hanging out clothing in the drying area of a commercial laundry. The actual setting of the picture is Gennevilliers, not far from Paris, located across the Seine from Argenteuil. In the distance we see the factory chimneys that were transforming the outskirts of Paris. The phenomenon of a commercial laundry was as new as the factories. Typically, before the middle of the nineteenth century, the wealthy would have such a plentiful supply of linen, clothing, and servants that washing and ironing on a large scale could be done only occasionally and in-house. Changing standards of hygiene, a growing entrepreneurial middle class, and a disenfranchised lower class (to provide the labor) are all reflected in the growth of laundering as a commercial activity. With such a choice for subject, Morisot was not only pointing up the social changes at work but also challenging conventional notions of subject matter appropriate for academic art.

Hanging the Laundry Out to Dry.
Berthe Morisot.
1875.
Oil on canvas.
13 × 16 in.
(33 × 40.6 cm).
The National Gallery of Art, Washington, D.C.

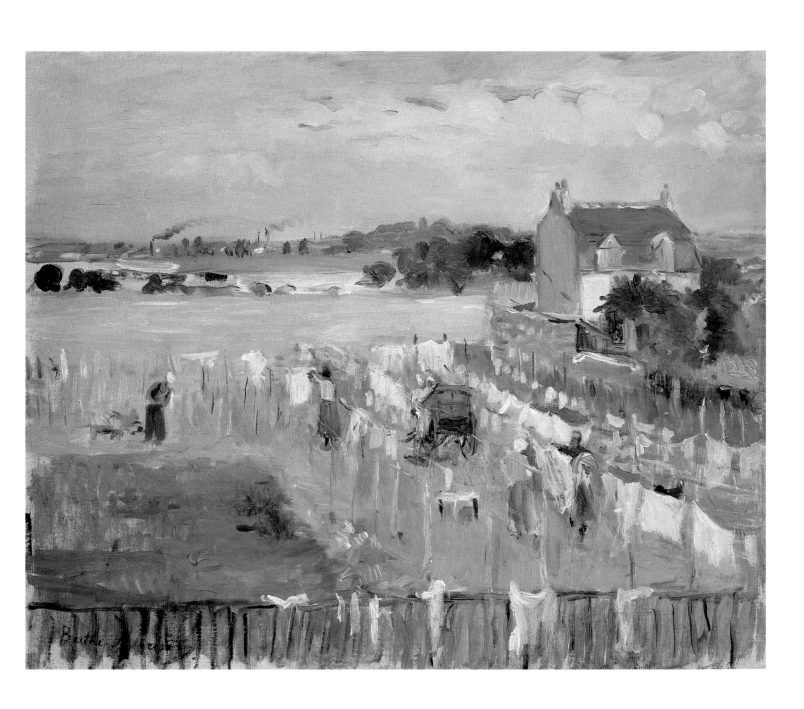

Climbing Path, L'Hermitage, Pontoise

CAMILLE PISSARRO

This audacious and original painting was executed out-of-doors less than a few minutes distance from Pissarro's home at the time. Most of Pissarro's paintings from Pontoise include figures, but he also made pure landscapes such as the *Climbing Path*. As his vantage point for this picture, Pissarro selected a site midway up a steep footpath on the Côtes des Boeufs, a hillside opposite the village of L'Hermitage. Rather than choose a picturesque or panoramic view of L'Hermitage, Pissarro represents a fragment of the landscape. Traditionally, landscapes had featured a low viewpoint with a broad open foreground that receded into distance toward a horizon. Despite elements in the picture that indicate recessional space implying depth, such as the path on the right margin of the painting, both the overall composition and paint handling belie depth of field. Landscape painters had typically used loose and broad brushwork for elements in the foreground with progressively smaller touches of paint used toward the distant horizon. Pissarro's varied brushwork does not conform to this convention. He employed a palette knife in addition to the brush to make this picture, and the resulting paint surface is uniformly dense and rough. The idea of a fragment as a viable subject of landscape painting is brilliantly realized by Pissarro in this remarkable and innovative picture.

Pissarro boldly insists upon the tactile quality of paint on the flat, two-dimensional surface of the canvas. The chaotic facture of the palette knife and brush is balanced by a relatively restricted palette of green and earthtones enlivened by touches of blue, orange, purple, and white. Painted quickly on the site, the *Climbing Path* has the appearance of direct and unmediated observation. At first, it seems that nature dominates the picture with only the path, a foreground wall, and a cluster of houses as reminders of man's presence. In nature, however, Pissarro found and used diagonals to structure the fragmentary landscape, a method which further emphasizes the picture's surface.

Pissarro and Cézanne frequently worked together at Pontoise and Auvers during the early 1870s. Pissarro introduced Cézanne to open-air painting and encouraged him to lighten his palette. Ultimately, Cézanne affected Pissarro's practice. The order and structure of the *Climbing Path* resemble Cézanne's compositions from this period (see Cézanne's *House of Père Lacroix*, page 46). Both painters rejected the informality and rendering of fleeting effects of light and atmosphere in favor of a more formal approach to landscape painting.

Agrarian France was changing rapidly during Pissarro's stay in Pontoise and its environs. Even though the village is a small or minor component of the picture, late nineteenth-century viewers would have recognized the modernity of the scene. Traditionally, houses in this region of France were built with rough stone and wood or thatched roofs. The structures in the distance represent new, more modern buildings. During the second half of the century, the walls of new homes were covered with stucco, usually painted white, and the roofs covered with brightly colored tiles.

Climbing Path, L'Hermitage, Pontoise.
Camille Pissarro.
1875.
Oil on canvas.
21 1/8 × 25 in.
(54 × 65 cm).
The Brooklyn Museum, New York. Purchased with Funds Given by Dikran K. Kelekian.

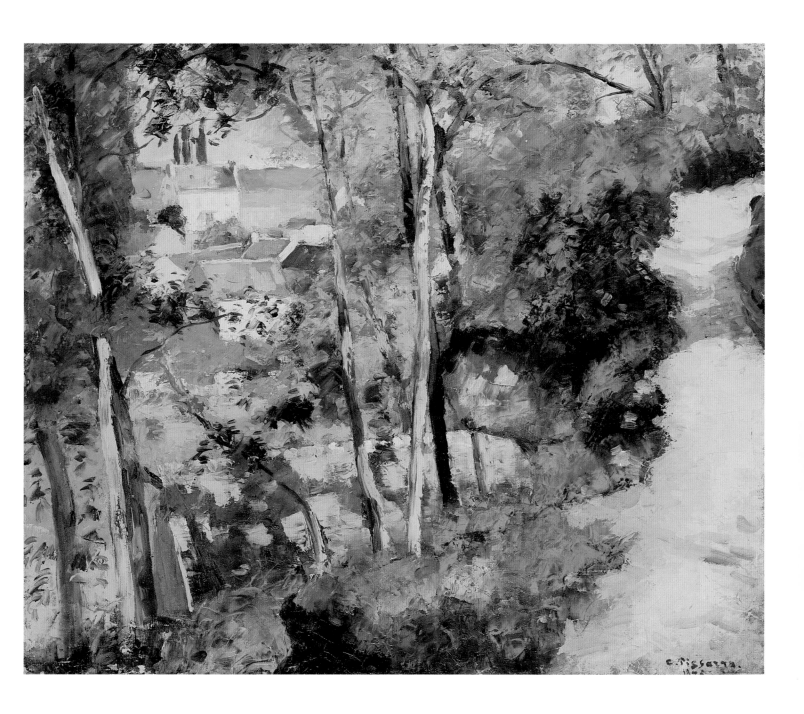

Boulevard St-Denis, Argenteuil, in Winter

CLAUDE MONET

Boulevard St-Denis, Argenteuil, in Winter.
Claude Monet.
1875.
Oil on canvas.
24 × 32 ⅛ in.
(60.9 × 81.5 cm).
Museum of Fine Arts, Boston.
Gift of Richard Saltonstall.

In December 1871 Monet moved into his first rented home in Argenteuil at 2, rue Pierre-Guienne near the northern end of the railroad bridge. After the completion of a rail line from Paris to this suburb in 1851, Argenteuil very quickly became one of the most popular resort towns within easy and convenient reach of the French capital. During his first years at Argenteuil, Monet found the motifs of some of his favorite subjects in this leisured landscape, concentrating on the river, with its sailboats, promenades, and bridges, and looked, to a lesser extent, to the developing edges of the town and the garden of his new home. In October 1874 Monet left this home on the rue Pierre-Guienne for a recently built house nearby on the boulevard Saint-Denis. The *Boulevard St-Denis, Argenteuil, in Winter* may be taken as representative of the painter's commitment to pure landscapes rather than the figure paintings and marines of the previous decade.

This painting is one of approximately fifteen winter landscapes that Monet executed during the early part of 1875. Here, the motif of winter is applied to an eastward view down the boulevard Saint-Denis toward the large railroad station to which the figures on the path presumably are making their way through the inclement weather. *Boulevard St-Denis, Argenteuil, in Winter* includes Monet's newly rented home: it is the house on the far right with a steep roof and green shutters.

Included among Monet's eighteen paintings in the second Impressionist exhibition of 1876 was a winter landscape painted in a style similar to *Boulevard St-Denis, Argenteuil, in Winter*, titled *Path of Epinay, Snow Effect*, now at the Albright-Knox Gallery, Buffalo, New York. The majority of the critics failed to see the effort and deliberation put into that painting, and we may safely assume that some of the same attitudes might have prevailed in the case of *Boulevard St-Denis, Argenteuil, in Winter*. In *Le Figaro*, the influential critic Albert Wolff wrote: "I have seen very interesting landscapes by him [Monet]. For a moment I thought that the creator of these impulsive sketches, glib but sensitive impressions of nature, would become someone. And now here he is, stuck forever in a mess he will never get himself out of." In *Le Siècle* the critic Henry Havard recognized the "effort" but disapproved of the results: "As for technique, it is trying; it seems difficult and overworked. Using impasto [heavily layered pigment] excessively, they [Monet and Pissarro] work for an ease of appearance that is earned only by effort. Here again some curious works are produced—instructive, but not decisive."

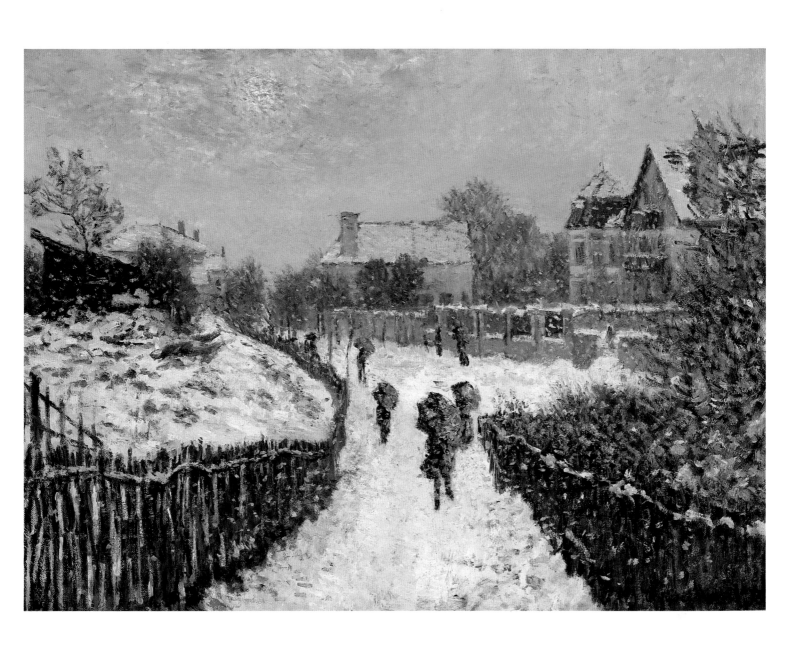

Camille Monet and a Child in the Artist's Garden at Argenteuil

CLAUDE MONET

The setting of this picture is the garden of the second house—on the boulevard St-Denis—that Monet leased in Argenteuil in June 1874, and into which he and his family moved in October. There are about fifteen paintings of the garden attached to Monet's first home, and several of these include his wife, young son Jean, and sometimes the family's maid. Both Renoir and Manet had painted Monet's family in this earlier garden. The motif of the private garden was popular with several of the Impressionists but it was Monet who would relentlessly exploit such sites throughout most of his career.

At Argenteuil Monet became an avid gardener. The bourgeois garden was a recent social phenomenon that had developed in France during the second half of the nineteenth century. Before this time, the self-contained private flower garden, as a feature of a middle-class home, simply did not exist. It is probable that Monet planned and laid out the garden at the newly built "Pavillon Flament," so named after the owner of the property. A large circular lawn in the middle of the garden was bordered by flowers on both sides. At the garden's far end were clusters of ornamental flowers, including hollyhocks and gladioli. Beyond these flower beds was an area filled with trees. It is generally believed that Monet executed five paintings of his new garden in 1875, including this picture, and in 1876, a further group of ten.

When this painting was sold by Monet to Clément Courtois in October 1875, it was simply titled *Seated Woman*. The picture, however, depicts the artist's wife, Camille, wearing a fashionable striped dress, and an unidentified child in a simple frock sitting on the edge of a path bordered by a small passage of green lawn. Behind the figures, a bed of colorful red and pink flowers—perhaps dahlias—fills the background. While Camille sews, a common grenre theme, the young child intently examines a book instead of playing with the small toy horse nearby. Since Monet has prominently dated this work 1875, the setting is the garden of the second house he leased in Argenteuil. The intense, almost shrill, palette of the picture competes with Madame Monet and the child for our attention; the elaborate flowering background, rather than the figures, becomes the focal point of the composition.

Contrasting this picture with Renoir's *A Girl with a Watering Can* (see page 64) of the following year reveals the profound differences between two artists equally engaged with garden settings by the mid-1870s. Although Renoir's composition is certainly not conventional, the figure remains the most important element of the work. Monet's treatment of the figure here represents a revision of the figurative tradition of Western painting: figure and background co-exist in this composition.

Camille Monet and a Child in the Artist's Garden at Argenteuil. Claude Monet. 1875. Oil on canvas. 21 3/4 × 26 1/2 in. (55.3 × 64.7 cm). Museum of Fine Arts, Boston. Anonymous Gift in Memory of Mr. and Mrs. Edwin S. Webster.

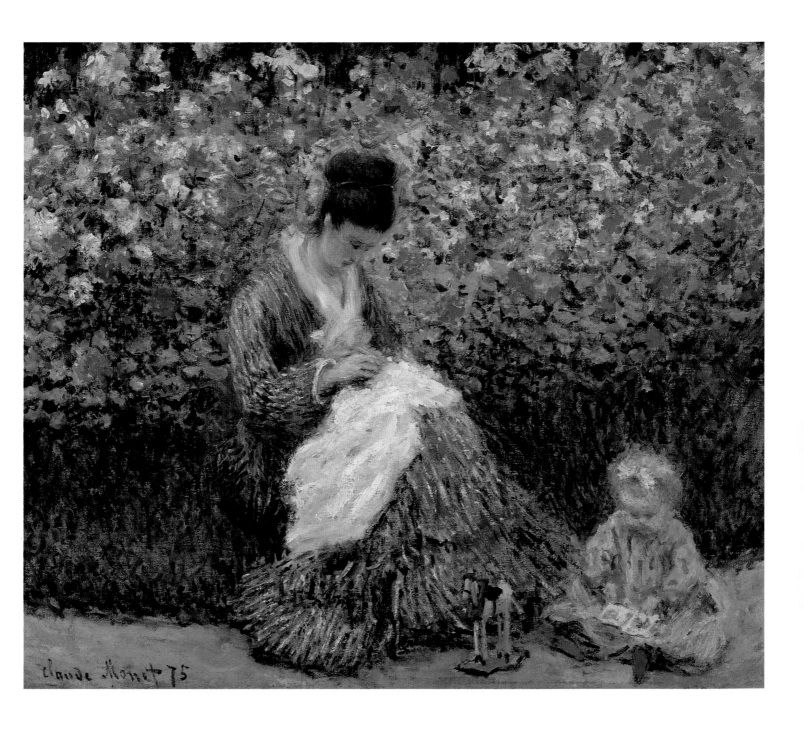

Grapes and Walnuts on a Table

ALFRED SISLEY

According to the hierarchy of genres championed by the Academy of Fine Arts and academic artists, still life was long considered to be the least noble or worthy subject matter. During the mid-nineteenth century, however, interest in still life in general and more specifically Jean-Baptiste-Siméon Chardin's eighteenth-century treatment of this motif, resulted in a reconsideration of its merits. Writing of Chardin, nineteenth-century critics Edmond and Jules de Goncourt praised "his beautiful buttery brush strokes, the curves of his fat brush in the full impasto, the charm of his blond harmonies, the warmth of his backgrounds, the brightness of his whites, gleaming from the sun."

The Impressionists shared the enthusiasm of the Goncourt brothers. Throughout the 1860s and 1870s conventional artistic training continued to be preoccupied with the figure and the elevated subjects of history. But although the champions of conservative aesthetic beliefs still criticized still life for the simplicity of its motifs, the new popularity and interest in still life painting overshadowed its detractors. The Impressionists' innovations are chiefly found in landscapes but they also experimented with and revitalized the genre of still life.

Alfred Sisley rarely painted still lifes, and fewer than ten pictures of this subject are attributed to him. Thus *Grapes and Walnuts on a Table*, painted in 1876, is rare among his body of work. Against a plain background featuring a purplish and beige wall, Sisley places the corner of a table with a plate of grapes, a knife, and a nutcracker. The simplicity of this modest arrangement of fruit and objects is indebted to Chardin's example. Sisley, like Manet, exploits the luminescence of the pure white tablecloth as the backdrop for the brown gnarled walnuts, the bright glimmer of the green grapes enlivened with touches of white, and the warm reds of the apples. His palette and his emphasis upon the play of light on various textures of objects recalls Monet's work in this genre at the same time. Clearly, these artists shared an interest in subjects other than landscape, and during the 1870s treated even the humblest of objects with their special genius.

Grapes and Walnuts on a Table remained in the artist's possession until 1881, when it was purchased by the dealer Paul Durand-Ruel for his private collection. In 1925 the painting was sold to American collector John T. Spaulding, who subsequently included it with many other Impressionist paintings in his bequest to the Museum of Fine Arts, Boston, in 1948.

Grapes and Walnuts on a Table.
Alfred Sisley.
1876.
Oil on canvas.
15 × 21 3/4 in.
(38 × 55.4 cm).
Museum of Fine Arts, Boston.
Bequest of John T. Spaulding.

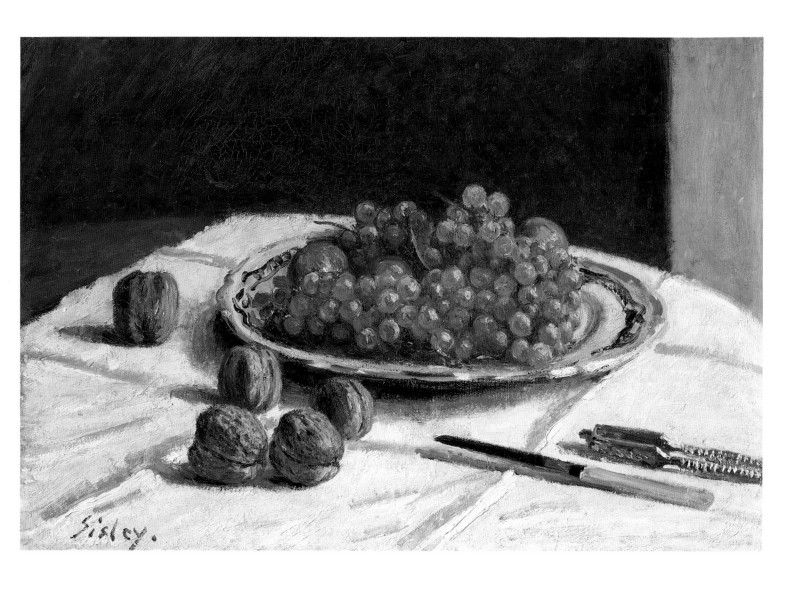

A Girl with a Watering Can

AUGUSTE RENOIR

The year 1876 was one of the most productive of Renoir's career. Painted during the spring or summer of that year, *A Girl with a Watering Can* is representative of Renoir's favored motif of women and children set in gardens or landscapes. More than any of the other Impressionists, including Degas, Renoir retained a traditional commitment to the figure as the basis of his art. Unlike the other Impressionists, he relied on portraiture as a means of support throughout his career.

In May 1876 Renoir rented a studio at 13, rue Cortot in Montmartre, then more of a suburb than part of Paris's city center. Behind the studio was an informally cared-for garden that served as the site of many of Renoir's works from this year. The elegant dress of the child in *A Girl with a Watering Can* and her garden toy, a tiny watering can, suggest that she was not a resident of this working-class and bohemian neighborhood. The identity of the young girl is uncertain, and the garden in which she stands appears more carefully maintained than the overgrown flowerbeds at the rue Cortot. Stylistically, however, this picture is related to other paintings set in this location.

The composition and technique of *A Girl with a Watering Can* are quite characteristic of Renoir's Impressionist style of the mid-1870s. Despite the informality of the subject, the surface of this painting is the product of careful deliberation. The rapid and spontaneous brushwork in the paintings of Monet, Sisley, Pissarro, and Morisot at this time differs from Renoir's touch, which is more constrained and delicate. Yet his facture is extremely varied and complex. For instance, tight, short strokes in different directions are employed for the child's face, with broader and looser strokes used for the garden background. Renoir's methods also differ from the other Impressionists' techniques in his use of glazes and semiglazes, that is, translucent paint layers—diluted with turpentine or linseed oil—interacting with the pigments beneath them. The effect achieved by Renoir with this procedure helps to produce the sparkling luminosity of the picture. By placing the young girl in the immediate foreground, viewed from slightly above ground level, Renoir enhances the intimacy of the portrait. Less radical than Degas's compositions, the design of the curving path and patches of garden is nevertheless an unconventional device, presenting a partial space close to the picture plane without a horizon line. In addition, Renoir carefully orchestrates his palette to enliven passages of the picture. For example, the red ribbon in the child's hair is echoed by the color of her lips and the flowers in the upper left background.

In 1962 Chester Dale bequeathed his residuary fortune and his entire collection of 247 paintings and sculptures to the National Gallery of Art in Washington, D.C., including *A Girl with a Watering Can* and eight other Renoirs. Combined with previous gifts, the Dale donation totals 309 works of art. To see the Dale collection requires visiting Washington since, as a provision of his gift, Dale stipulated that his collection must remain on display at the National Gallery. If the National Gallery violates this stipulation, the entire bequest is to be transferred to The Metropolitan Museum of Art in New York.

A Girl with a Watering Can.
Auguste Renoir.
1876.
Oil on canvas.
39 1/2 × 28 3/4 in.
(100.3 × 73.2 cm).
The National Gallery of Art,
Washington, D.C.
Chester Dale Collection.

Bathers at Rest

PAUL CÉZANNE

On September 26, 1874, Cézanne wrote from Paris to his mother in Aix-en-Provence: "I must work continuously, not to attain some end, which gives rise to the admiration of idiots. This thing that is so appreciated by the vulgar is no more than mere craftsmanship, which makes any work it produces inartistic and commonplace. I must seek for completeness solely for the pleasure of working more truly and wisely. And believe me, a time always comes when one is recognized and gains admirers who are much more fervent and convinced than those who are only taken in by some vain surface appearance." In concluding his letter, Cézanne noted, apparently without irony, "The times are bad for sales, all the bourgeois are loath to relinquish a cent, but that will change." Several of the issues and concerns that Cézanne has raised here are reflected in one of his most ambitious and radical paintings from the second half of this decade, *Bathers at Rest*.

There is certainly nothing "commonplace" about *Bathers at Rest*. Of course, the motif of male figures in a pastoral setting had numerous precedents in Western painting, including very recent pictures such as Frédéric Bazille's *Summer Scene* (see page 34). The four figures in Cézanne's picture are rendered with a vigor and seemingly intentional crudity that challenge and indeed question the value of the "mere craftsmanship" usually expected in representations of the human form. Cézanne's handling of the flesh in a thick impasto, with independent black contours as outlines set against the landscape, is unprecedented. The disjunction between the figures, in terms of scale and psychology, contributes to the startling originality of the work. The landscape—with Mont Sainte-Victoire in the distance—is also painted in dense, modeled pigment. In his effort to achieve "completeness," the heavily laid-on paint surface is almost overwrought. This haunting, bizarre, and enigmatic painting is not about anatomical accuracy, or a balanced palette, or narrative legibility, or atmospheric effects—the "vain surface appearance"—but rather an attempt to revise or reinvent figure painting. In conventional terms, *Bathers at Rest* is deliberately and aggressively vulgar. But if we look at it in the light of Cézanne's letter, it is also (to the artist's mind) about "working more truly and wisely."

Cézanne's closing comment in his letter to his mother, about the lack of sales, may refer partly to the financial failure of the first Impressionist group exhibition that was mounted earlier that year. Of Cézanne's three entries, he did sell one, a landscape. He would not participate in the second group show of 1876, but in 1877 he exhibited sixteen or seventeen paintings at the third group exhibition, where he was given an entire wall. Most likely this is where he exhibited his *Bathers at Rest*. About this strange work, the sympathetic critic Cordey wrote in *L'Impressioniste*: "The painter of the *Bathers at Rest* belongs to a race of giants. Since he does not lend himself to comparisons with ordinary painters, it has been found convenient to deny him altogether; nevertheless he has respected his forerunners in art, and if his contemporaries do not do him justice, future ages will rank him among his peers, beside the demigods of art."

Bathers at Rest.
Paul Cézanne.
1875–76.
Oil on canvas.
32 1/4 × 39 7/8 in.
(82 × 101.2 cm).
The Barnes Foundation,
Merion, Pennsylvania.

Paris Street: A Rainy Day

GUSTAVE CAILLEBOTTE

G ustave Caillebotte was born on August 19, 1848, the son of a wealthy textile manufacturer. As a child, Caillebotte enjoyed the privileges of affluence, attending the Lycée Louis-le-Grand. He later studied law and received his bachelor's degree. During the Franco-Prussian War he served with the Garde Mobile de la Seine. Caillebotte eventually abandoned a legal career to become a painter; he entered the teaching studio of Léon Bonnat in 1872 and enrolled at the École des Beaux-Arts the next year. In 1875, Caillebotte submitted *Floor Scrapers*, now at the Musée d'Orsay, to the Salon jury. It was rejected. A year later, he exhibited this, along with seven other paintings, in the second Impressionist group exhibition of 1876. It was probably about this time, through Bonnat, that Caillebotte met Degas.

Caillebotte became not only a participant in the group exhibitions but also a patron and collector of his peers' paintings. The vast fortune he had inherited in 1874 enabled him to purchase Impressionist paintings, often at inflated prices, to aid his friends, and to contribute to the organizing of the independent group shows. Caillebotte played a greater part in the third group show, which included three large and ambitious works—including *Paris Street: A Rainy Day*, together with *The House Painters*, now in a private collection in Paris, and *The Europe Bridge, Variant*, presently at the Kimbell Art Museum, Fort Worth, Texas.

Paris Street: A Rainy Day and the other two works that Caillebotte exhibited in 1877 demonstrate his commitment to the depiction of modern life rather than the allegorical or historical representations the Salon had so long favored. The picture is set at the meeting of rue Moscu and rue Turin on rue de St. Petersburg. The meticulous draftsmanship and tight execution of *Paris Street: A Rainy Day* differ completely from the vibrant palettes and broken brushwork of Monet, Pissarro, Sisley, Morisot, Renoir, and Cézanne. In his review of the exhibition the critic Lepelletier believed that Caillebotte's work "would still figure honorably beside pictures receiving the approval of the Champs-Elysées [the official Salon] jury." Although the planning of *Paris Street: A Rainy Day* is typical of academic painting, the composition and modern subject matter are related to the common interests of the Impressionists. Caillebotte's manipulation of the pictorial space through linear perspective, with the two foreground figures appearing to stroll into the viewer's space, is as radical as any of Degas's unusual spatial schemes.

As early as 1876 Caillebotte drafted a will leaving his collection to the French state with the stipulation that the works hang first in the Musée Luxembourg and then the Louvre. At his death in 1894, sixty-nine paintings were offered to France. The bequest gave birth to a controversy that grew and endured for over two years. In a compromise the government finally accepted forty of the sixty-nine paintings. In keeping with his personal modesty, Caillebotte had not included any of his own work in the bequest. Among the paintings rejected by the state was Cézanne's *Bathers at Rest* (see page 66), subsequently purchased by Dr. Albert Barnes. Several of the remaining paintings are now found in American museums.

Paris Street: A Rainy Day.
Gustave Caillebotte.
1876-1877.
Oil on canvas.
85 1/2 × 108 3/4 in.
(212.2 × 276.2 cm).
Charles H. & Mary F.S.
Worcester Collection,
The Art Institute of Chicago,
Chicago, Illinois.

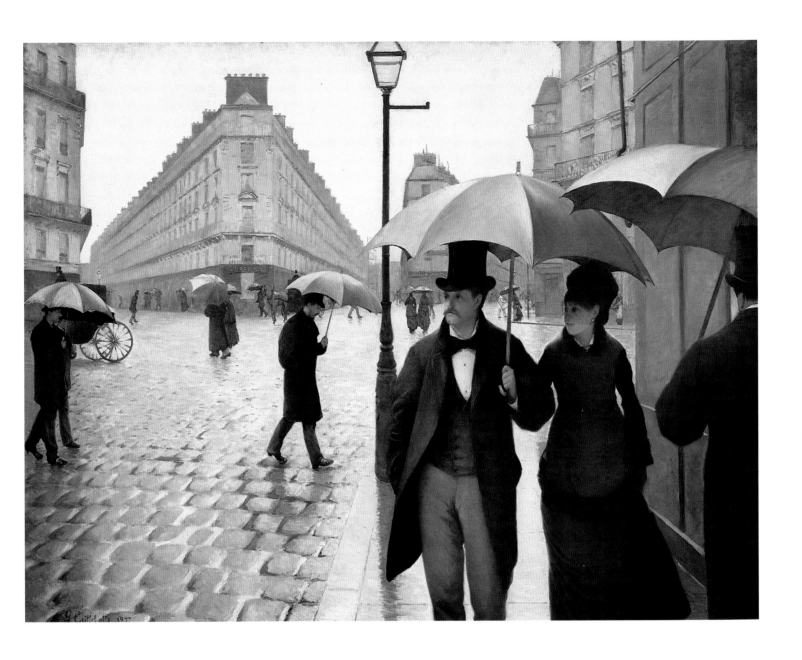

The Gare Saint-Lazare: Arrival of a Train

CLAUDE MONET

The largest of Monet's twelve paintings of this train station, this work was executed between January and April 1877. The Gare Saint-Lazare, reconstructed and enlarged during the 1860s, was the biggest and busiest railroad station in Paris. Monet knew the station well; it was the point of departure and terminus for trains along the Argenteuil route, where he then lived, and along the line to Le Havre, the home of the artist's family. Advances in train travel had increased dramatically during the 1850s and 1860s, and by the 1870s a vast network of railways permitted the rapid transportation of people and freight throughout France. Trains and the stations where it had been decided they should stop reflected the rapidly metamorphosing character of French culture and society. Perhaps more than any other technological advance, trains signified the speed of modernity — its blur. By selecting the Gare Saint-Lazare as his nearly exclusive subject for close to four months, Monet was certainly aware and prepared to capitalize on the symbolic associations of his subject. While trains had figured in many of Monet's landscapes from the 1870s, the motif then was mostly an element in the composition, not the subject itself.

In January of 1877 Monet leased a studio at 17, rue Moncey with 700 francs provided to him by his more affluent friend Caillebotte. In order to set up his easel in the chosen locations (at the end of one of the main lines) Monet obtained official permission from the station's manager. Renoir later told the story that Monet had presented himself to the station manager as quite the dandy, declaring: "I have decided to paint your station. For a long time I have hesitated between the Gare du Nord and yours, but in the end I think yours has more character." The station's personnel apparently even assisted Monet logistically, including delaying trains and arranging for extra smoke, all to accommodate Monet's conception of his motif.

The Gare Saint-Lazare: Arrival of a Train is one of four interior views of the station in the group of twelve. We do not know which of the twelve canvases were shown in the 1877 Impressionist group show (which also included Cézanne's *Bathers at Rest* and Caillebotte's *Paris Street: A Rainy Day*). Nevertheless, it is clear that this work is the most highly resolved painting in the group. The dense impasto completely covers the picture's surface. In the other versions of the station, Monet's technique is far looser, and in several examples he allows the primed canvas to show through. The Pont de l'Europe, a recently constructed bridge, is hidden behind the billowing smoke which is painted broadly in cursive strokes. In contrast, the trains are executed in a manner that suggests their massive physical presence. This group of pictures may be taken as Monet's last attempt to represent modernity in favor of a preoccupation with atmospheric effects.

The Gare Saint-Lazare: Arrival of a Train. Claude Monet. 1877. Oil on canvas. 31 5/8 × 38 5/8 in. (80.3 × 98 cm). Harvard University Art Museums, Fogg Art Museum, Cambridge, Massachusetts. Bequest of Collection of Maurice Wertheim, Class of 1906.

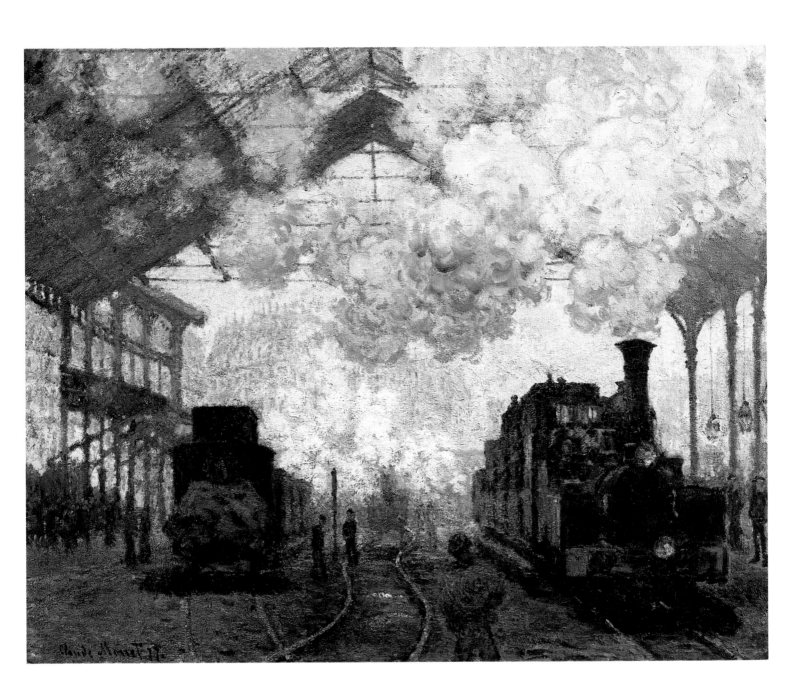

Madame Georges Charpentier and Her Children

AUGUSTE RENOIR

Dissension among the participants after the third Impressionist group exhibition in 1877 led to difficulties organizing the remaining shows, five in all. Degas insisted that the exhibitors in the independents' group shows commit themselves not to participate in the annual Salon exhibitions. This was necessarily troubling for Monet, Sisley, and Renoir, who, unlike Degas, needed to earn income from their art. Since the first three group shows and two independently organized auctions had been financial failures, Renoir decided not to participate in the fourth show in 1879 but rather to return to the Salon. He submitted two paintings to the Salon jury, one of which was *Madame Georges Charpentier and Her Children*. Both entries were accepted.

Renoir's choice of genre—portraiture—and subject—members of Georges Charpentier's family—was undoubtedly a calculated decision. Portrait commissions could provide a steady source of revenue, and the Charpentiers already had purchased one of Renoir's works as early as 1875. In addition, Georges and Marguerite Charpentier occupied a prominent social status in Paris. As the publisher of Émile Zola, Gustave Flaubert, and Edmond and Jules de Goncourt, Georges Charpentier was considered a champion of the most advanced tendencies in literature. Indeed, during the 1880s the Charpentiers set up a weekly journal, *La Vie Moderne*, intended to chronicle and celebrate modern tendencies in literary, artistic, and social activity in Paris. Mme Charpentier was also well known as the hostess of important literary and political soirées held in their Paris home. Renoir received 1,000 francs for this family portrait, but the publicity was perhaps even more valuable to the painter's reputation, and his purse.

Despite the informal appearance of this portrait, at least forty sittings were required by Renoir. Apparently, he selected a corner of the Charpentiers' home without rearranging the setting as a background for this group portrait. This was unusual. Conventional society portraits more often than not featured far simpler backgrounds, which placed the emphasis on the individual subjects. Mme Charpentier, in a black Worth dress, and her two elegantly dressed children are presented, along with the family's dog, Porto, off center in the composition, yet another departure from convention. The faces and hands of the sitters are rendered with more finish, still expected by the Salon jury, than the other elements in the picture.

The critical response in 1879 to this picture was mixed. In general critics praised Renoir's abilities as a colorist but found fault with his drawing. More conservative critics also carped on the unfinished quality of the picture, by now a familiar complaint. For example, Bertall complained that the portrait was "a very incomplete sketch done in accurate tones . . . a slack, transparent sketch, which seems to have been done with different colored balls of cotton wool." The writer and critic Joris-Karl Huysmans was more enthusiastic in his review: "It is an interesting experiment and deserves to be praised. . . . It is painted somewhat thinly, and the props the artist has introduced are rather garish, but it is skillfully executed and above all it is daring! In a word, this is the work of an artist who has talent and who is an independent, even if he does exhibit at the official Salon." Just what Renoir had in mind.

Madame Georges Charpentier and Her Children.
Auguste Renoir.
1878.
Oil on canvas.
60 1/2 × 74 1/8 in.
(153.7 × 190.2 cm).
Metropolitan Museum of Art, New York, Catharine Lorillard Wolfe Collection.

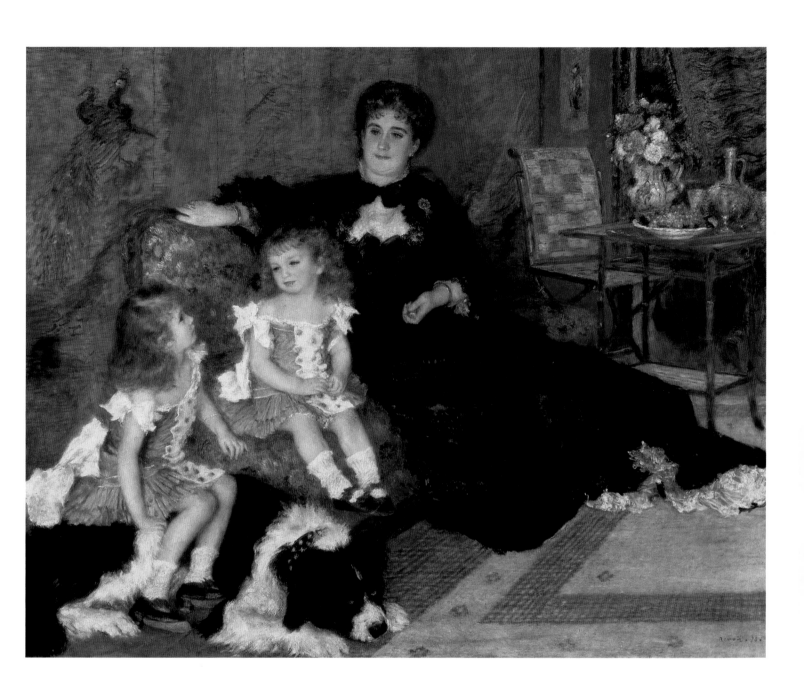

At the Opera

MARY CASSATT

*B*orn on May 22, 1844, Mary Cassatt, the daughter of a successful Pittsburgh banker, spent several years of her childhood in France and Germany. In America, between 1860 and 1865, Cassatt attended lectures at the Pennsylvania Academy of the Fine Arts in Philadelphia. In 1866 she returned to France to further her studies, where she applied for the required permit to make copies of paintings in the Louvre and briefly enrolled as a student of the academic painters Charles Chaplin and Jean-Léon Gérôme. Forced to return to the United States by the Franco-Prussian War, she traveled to Europe again in December 1871. In 1874, Cassatt's *Ida* attracted the attention and praise of Edgar Degas at the Salon and, in 1877, she met Degas and was invited to participate in the fourth Impressionist group exhibition in 1879. She exhibited eleven works in this show and received a favorable response.

At the Opera, although compositionally somewhat atypical, belongs to a series of paintings based on theater motifs made by Cassatt between 1878 and 1880. Painted on modestly sized canvases, these images of the theater range from the conventional to the boldly experimental, with *At the Opera* being an example of Cassatt's more innovative work. Contrasting the abbreviated brushwork used for the figures in the background loges with the tighter execution and refinement of the foreground figure, Cassatt, like the other Impressionists, challenged the academic ideal of finish (*fini*). Cassatt's preference for interiors rather than the natural light and color of out-of-doors painting distinguishes her work from her Impressionist colleagues. Cassatt, in painting many interior scenes in artificial light, was probably following the lead of Degas. Additionally *At the Opera* is perhaps indebted to Manet's extensive use of black and his dramatic contrasts of lights and darks. The probable precedents for *At the Opera* should not, however, obscure its originality. The elegantly austere woman in the foreground is not presented as a sensual object for the male gaze, as in Renoir's pictures of this subject, but rather as an autonomous spectator-theatergoer in her own right.

The theater, and the opera in particular, served as pretexts for socializing during the Second Empire and Third Republic. A contemporary of Cassatt's noted: "To see and to discuss acquaintances, and to be seen and discussed by them, and (for men) to go gossiping from box to box are . . . the main objects with which 'the world' goes to the Opera." Upper-class women had to rely on their opera glasses to scrutinize not only the performance but also its audience. As the woman in *At the Opera* intently fixes her gaze, aided by her opera glasses, on another loge across the theater, a man leans forward with his opera glasses to gaze at her in this masterful representation of social mores.

At the Opera was first exhibited in the United States and was purchased by the Museum of Fine Arts, Boston, in 1910. The painting had been included in the Society of American Artists second annual exhibition in 1879, the same year that Cassatt established her lifelong friendship with Louisine Elder (the future Mrs. Havemeyer). Cassatt encouraged the Havemeyers to become active collectors of French Impressionism.

At the Opera.
Mary Cassatt.
1879.
Oil on canvas.
31 1/2 × 25 1/2 in.
(80 × 64.8 cm).
Museum of Fine Arts, Boston.
Charles Henry Hayden Fund.

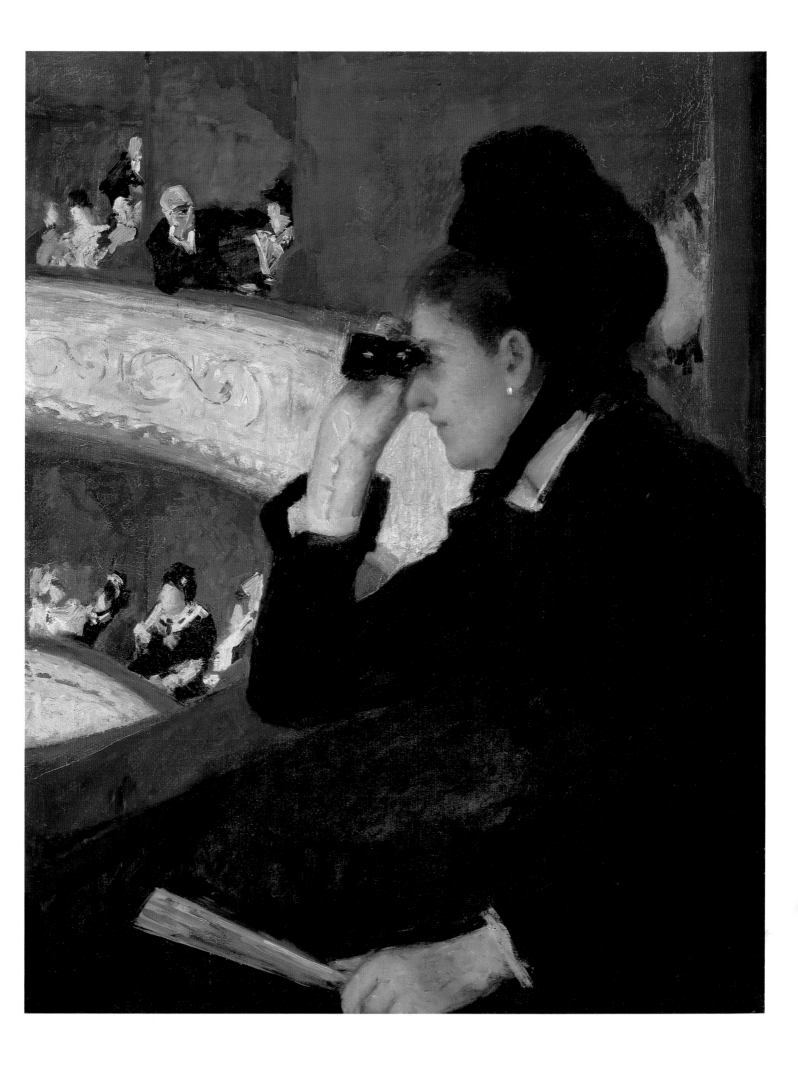

Entrance to the Village of Vétheuil in Winter

CLAUDE MONET

On September 1, 1878, Monet wrote to his patron Eugène Murer that he had moved "to a ravishing spot on the banks of the Seine at Vétheuil." Unlike Argenteuil, Vétheuil had no industry, no railroad, and no tourists. In 1878 the small village had a population of only 622, most of whom were farmers. The conspicuous absence of modernity from Vétheuil and its surrounding pristine landscape attracted Monet. The move from Argenteuil, however, was also practical. Monet was once again experiencing financial difficulties and needed a less expensive place to live, especially since the birth of his second son, Michel, in March 1878. Moreover, Monet and Ernest Hoschedé, the former department-store magnate and art speculator who had declared bankruptcy in 1877, decided to establish a common household. Hoschedé, his wife (with whom Monet was romantically involved), and their six children, together with the Monet family, moved into the first house on the left side of the road in this picture.

The village of Vétheuil faced the hamlet of Lavacourt and provided a view of the open meadows across a bend in the Seine. From the summer of 1878 through November 1881, Vétheuil and its environs became the principal subject of Monet's paintings. He rarely traveled more than a few hundred yards from his home, rendering the seemingly timeless landscape of rural France, so different from the industrial and leisured setting of Argenteuil. In 1879 Monet wrote to Théodore Duret: "I have become a country-dweller again . . . I only come to Paris very rarely to sell my canvases."

The move to Vétheuil coincided with changes and refinements in Monet's Impressionist style. He continued to paint with a series of *taches*, that is, colored patches, deploying a variety of strokes, some small and irregular, others broad and fluid. The thinly painted surface of *Entrance to the Village of Vétheuil*, however, differs from the densely painted *Boulevard St-Denis, Argenteuil, in Winter* (see page 58). Monet's interest in the changing effects of weather rather than the landscape itself, evident in the present work, had become paramount.

Entrance to the Village of Vétheuil in Winter.
Claude Monet.
About 1879.
Oil on canvas.
23 ⅞ × 31 ⅞ in.
(60.6 × 81 cm).
Museum of Fine Arts, Boston.
Gift of Julia C. Prendergast in Memory of Her Brother, James Maurice Prendergast.

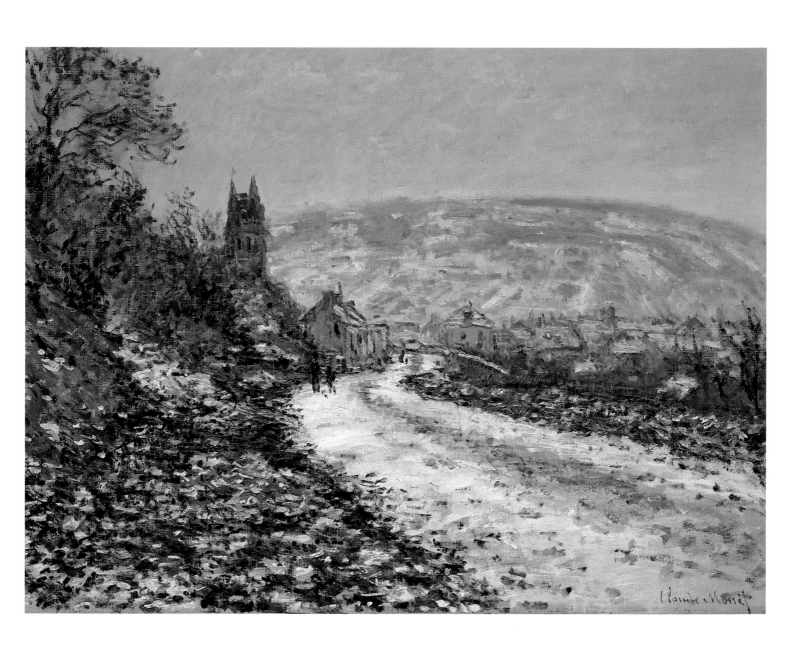

The Market Gardens of Vaugirard

PAUL GAUGUIN

Paul Gauguin was born in Paris on June 7, 1848. The next year the family left France for Peru, and during the voyage Gauguin's father died. By the beginning of 1855, Aline Gauguin had returned to France with her two children. By 1862, Paul had decided to prepare himself for the Naval Academy. Unsuccessful in his attempt to enroll in the academy, he eventually enlisted in the navy as a third-class sailor. He sailed extensively in the Mediterranean and afterward on a voyage to the North Pole. After serving in the Franco-Prussian War, Gauguin left the navy and, in 1872, was hired as a stockbroker by Paul Bertin in Paris.

Gauguin began to paint, on a part-time basis, the following year. Although self-educated, he exhibited successfully at the Salon in 1876. He resigned from Bertin's firm later that year and moved to the Vaugirard neighborhood of Paris. In 1879, Degas and Pissarro invited Gauguin to participate in the fourth Impressionist exhibition; he showed a bust of his son, and a year later, in the fifth Impressionist group show, he exhibited eight works, including *The Market Gardens of Vaugirard*.

Within this carefully considered composition, Gauguin has responded, first, to the example of Pissarro, applying his paint in tight, short interwoven strokes. Vertical accents provided by the trees are set against the predominant horizontal thrusts that give the picture a rigid order. Gauguin's work is considerably indebted, in the second place, to the example of Cézanne, although after the latter's participation in the third Impressionist show of 1877, he had withdrawn from the Paris avant-garde. Nonetheless, through Émile Zola, Gauguin must have known Cézanne's *Château at Médan*, dated about 1879–80, now at the Burrell Collection, Glasgow, which is also characterized by strong horizontal zones. Gauguin's picture is more deliberate and precise than Cézanne's methodical yet intuitive paint handling. It is noteworthy that Gauguin would later acquire this Cézanne from Julien Tanguy (often called père Tanguy, who was the first to handle Cézanne's works).

It is likely that the specific motif of a market garden was suggested to Gauguin by Pissarro, who had a predilection for agrarian themes. Small market gardens had traditionally provided Paris with produce throughout the nineteenth century. After the completion of a railway link between Paris and Nice in 1870, it was possible to transport fruit and vegetables from the warmer southern region to the capital in about twenty-four hours. The type of garden represented by Gauguin was thus economically threatened by the advances of the French rail network.

Gauguin's thoughts followed Cézanne even after he had finished the painting. During the spring of 1881, Gauguin spent his vacation with Pissarro in Pontoise where Cézanne was also working. In a letter following his visit Gauguin wrote to Pissarro: "Has Monsieur Cézanne found the exact formula for a work acceptable to everyone? If he discovers the prescription for compressing the intense expression of all his sensations into a single and unique procedure, try to make him talk in his sleep by giving him one of those mysterious homeopathic drugs and come immediately to Paris to share it with us."

The Seine at Lavacourt

CLAUDE MONET

For Monet, 1880 was a significant year. He declined to participate in the fifth Impressionist exhibition in April, returned to the Salon in May, and had his first one-man exhibition in June at the offices of Georges Charpentier's *La Vie Moderne*, a lavish publication that also printed the first interview with the artist during the run of the exhibition. Although the Salon jury had treated Monet harshly during the late 1860s, he would certainly have noted the acceptance of Manet's *Argenteuil*, now at the Musée des Beaux-Arts, Tournai, at the Salon of 1875, a picture that he and his wife had posed for during its preliminary planning, as well as Manet's *Boating* at the Salon of 1879 (see page 52). Renoir, too, had submitted successfully one painting to the Salon of 1878 and four in 1879. Monet must have been aware of the new position taken by a more liberal government whose spokesman, Jules Ferry, wrote: "We have an entire new school . . . which, not satisfied in seeking the truth as it was once understood—the truthfulness of the studio—pursues a more fugitive but also more intimate truth, more difficult to seize but all the while more startling, what one calls today the truth of *plein air* (out-of-doors)."

Monet had the Salon in mind during the winter and spring of 1880 when he executed several unusually large paintings; these were almost twice the scale of the landscapes he had been exhibiting at the Impressionist shows. Although modernity had figured prominently in his paintings of the early to mid-1870s, his Salon submissions of 1880 are notable for the absence of references to contemporary culture and for their more conventional compositions. By the late 1870s, Monet abandoned the pleasure boats, trains, weekend pleasure-seekers of Argenteuil, and the urban imagery of Paris that had been his primary subject matter earlier that decade. The present picture, *The Seine at Lavacourt*, was executed during the early spring and simply presents a bucolic vista with the village in the distance beyond the river.

Not only did Monet change his subject matter at this time, he also seemed to temper his stylistic innovations. The strident colors in paintings such as *Camille Monet and a Child in the Artist's Garden at Argenteuil* (see page 60) are replaced by more muted hues. Indeed, Monet wrote to Duret on March 8, 1880: "I am working hard at three large canvases, only two of which are for the Salon, because one of the three is too much to my taste to send, and it would be refused, and I ought instead to do something more discreet, more bourgeois." Despite the more progressive attitudes of Ferry and other government officials, the jury only accepted the more conventional or "bourgeois" of Monet's two paintings, *The Seine at Lavacourt*. The painting was then "skyed" during the installation of the Salon, that is, hung on the uppermost tier of pictures, making it very difficult to see.

Despite its undesirable location, several Salon reviews made mention of *The Seine at Lavacourt*. Zola described Monet as "an incomparable landscapist." He cited Monet's courage in returning to the Salon but cautioned the artist that "his need of sales" should not result in hastily executed pictures. On the other hand, in *La Républic Française*, Burty maintained that Monet should not have deserted the Impressionist exhibitions, observing that the public no longer came to laugh but rather to buy.

The Seine at Lavacourt.
Claude Monet.
1880.
Oil on canvas.
38 ¾ × 38 ¾ in.
(98.4 × 149.2 cm).
The Dallas Museum
of Art, Dallas, Texas.
Munger Fund.

Overcast Day at Saint-Mammès

ALFRED SISLEY

During the fall of 1877 Sisley moved from Marly-le-Roi to the more industrial town of Sèvres, and then in late 1879 or early 1880 he moved again, this time to Veneux-Nadon, a rural area two hours by train southeast of Paris. This move put him even farther from his friends, Monet and Pissarro, who had settled closer to Paris in its northwest suburbs. Veneux-Nadon had remained a small rustic town unaffected by the industrial growth of the Third Republic.

This picture, *Overcast Day at Saint-Mammès*, depicts this small village located near the confluence of the Loing and Seine rivers. Sisley's latest move coincided with slight changes to his earlier Impressionist style. The close fidelity to the appearance of his subjects in his previous works has been replaced by a bolder palette and looser handling of pigment. Sisley's facture, or execution, is rougher and more varied in this picture than in his work of the 1870s. The composition, however, remains one frequently used by the artist. The view consists of a receding road bordered on one side by a row of houses and on the other by the Loing river, which carries the observer's gaze into the distance. The small boat and two paddle wheel–driven barges show a river without either the leisure or commercial vessels of Argenteuil, much less the factories that border the Oise river in Pissarro's paintings of Pontoise. Sisley's move to Veneux-Nadon occurred soon after Monet left the suburb of Argenteuil and Pissarro departed from Pontoise. Although conspicuous motifs of modernity had not figured prominently in Sisley's earlier imagery, his move in the early 1880s is part of a broader pattern of retreat from contemporary culture to a more bucolic, preindustrial conception of the French landscape.

Overcast Day at Saint-Mammès was one of twenty-six paintings that Sisley exhibited in the seventh Impressionist exhibition of 1882. In his review of the exhibition for *Le Chat Noir*, Henri Rivière wrote, "Decidedly, it is still Monet who is the chief landscapist of the little school [the Impressionists]." Rivière's remarks are unintentionally ironic since the styles of Monet, Sisley, and the other Impressionists began to differ significantly in the early 1880s. Although Sisley's handling is bolder in *Saint-Mammès*, it remains subordinate to the rendering of actual tangible forms, unlike Monet's greater interest in the atmospheric effects of light and color, which tend to dissolve the object. The perceptive novelist and critic Joris-Karl Huysmans noted in his review of the exhibition for *L'Art Moderne*: "Sisley, along with Pissarro and Monet . . . [was] one of the first to go directly to nature, to dare heed her, and to try to remain faithful to the sensations he feels before her. His artist's temperament is less picky and nervous, his eye is less delirious, than those of his two fellow artists."

Overcast Day at Saint-Mammès.
Alfred Sisley.
About 1880.
Oil on canvas.
21 ⅝ × 29 ⅛ in.
(54.9 × 74 cm).
Museum of Fine Arts, Boston.
Juliana Cheney Edwards Collection.

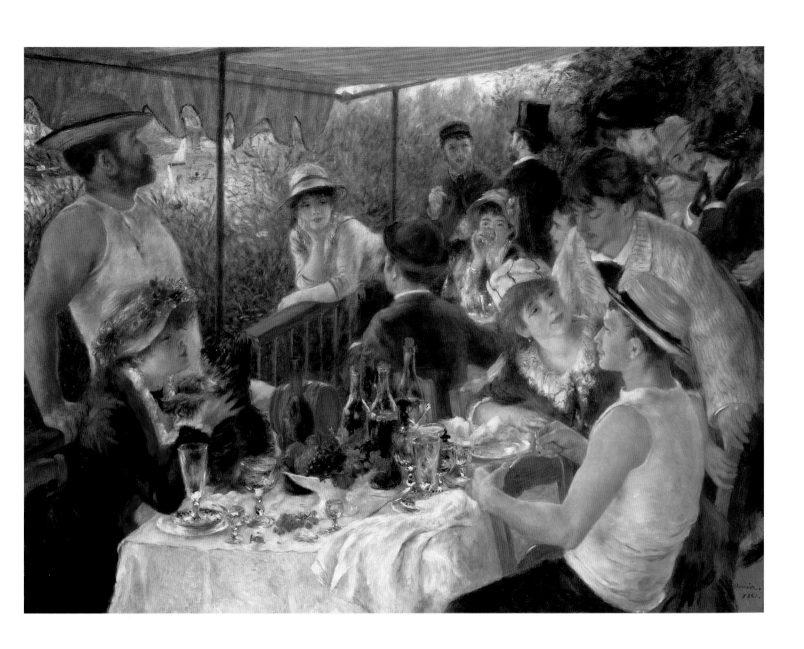

Fisherman's Cottage on the Cliffs at Varengeville

CLAUDE MONET

Fisherman's Cottage on the Cliffs at Varengeville.
Claude Monet.
1882.
Oil on canvas.
23 7/8 × 32 1/8 in.
(60.5 × 81.5 cm).
Museum of Fine Arts, Boston.
Bequest of Anna Perkins Rogers.

From 1881 on, Monet frequently left his studio and family for extended periods, ranging from several weeks to several months, in search of new motifs. During the early 1880s he returned to his native Normandy coast. Monet first traveled to Les Petites Dalles in 1880 and then Fécamp and the Seine estuary in 1881. Early in February 1882 Monet once again traveled to the Channel coast. In mid-February he settled in the village of Pourville, staying through mid-April. Thus Monet spent nearly six months at Pourville painting about ninety-six seascapes. Seventeen of these pictures include the coast guard's cottage or the "fisherman's house" (*maison de pêcheur*), as Monet often referred to the building. (These small cabins were built by Napoleon as shelters for the watchmen who were to keep an eye on the English.) Monet wrote to his companion Alice Hoschedé from Pourville on April 4, 1882: "How lovely the countryside is becoming, and what a joy it would be for me to show you the delightful places there are to see here!" Monet's new subject matter can be interpreted as a rejection of modernity in favor of natural vistas unaffected by the social and economic developments of the Third Republic (1870–1938).

Monet chose his sites with great care; the isolated cabin on the cliff of the Petit-Ailly was visible from several points nearby providing a wide range of possible vistas. Yet Monet would still adjust his compositions to conform to his aesthetic goals. He may have had other goals in mind as well. As it sometimes turned out, the painter's motifs were often the much-favored natural sites announced in guidebooks. The scenic cottage painted by Monet, for example, was featured on the contemporary postcards of this tourist locale.

Fisherman's Cottage on the Cliffs at Varengeville is marked by a brilliant palette and wide variety of brush strokes. Dense calligraphic brushwork of contrasting hues represents the lush foliage and flowers in the foreground. Fluid horizontal strokes of blues, greens, and violets depict the calm and luminous sea beyond the cliff's edge. When Monet returned to this site in the 1890s, he produced a series of paintings less concerned with the actual colors of the seascape or texture of forms than with the subjective manipulation of almost monochromatic hues. After his arrival in Pourville in 1897, Monet wrote happily to Alice Hoschedé, by then his wife: "Nothing has changed. The little house is intact, and I have the key."

The Gulf of Marseilles Seen from L'Estaque

PAUL CÉZANNE

*The Gulf of Marseilles Seen
from L'Estaque.
Paul Cézanne.
1882–85.
Oil on canvas.
28 3/4 × 39 1/2 in.
(73 × 100.4 cm).
The Metropolitan Museum
of Art, New York. The H.O.
Havemeyer Collection, 1929.*

Beginning in 1870, Cézanne frequently visited the Mediterranean village of L'Estaque west of Marseilles. He returned in 1876, producing more than a dozen canvases over the next ten years featuring marine landscapes in the clearer, brighter light and purer atmosphere of the south of France. Unlike Monet, and to varying degrees the other Impressionists, who continued to be preoccupied by ephemeral atmospheric effects, Cézanne sought to render nature in a more permanent yet still original manner. It is significant that Cézanne selected a high vantage point for his composition. The panoramic vista differs from the discrete and unpicturesque landscapes that Cézanne had painted at Auvers and Pontoise the previous decade (see *House of Père Lacroix*, page 46). In this respect, Cézanne returned to a more classical and traditional conception of landscape by rejecting a fragmentary passage of nature in favor of grandeur and monumentality. Despite the factory chimneys and buildings in the foreground of *The Gulf of Marseilles Seen from L'Estaque*, the presence of man is suppressed; marine traffic in the busy gulf is entirely absent.

This canvas and two other closely related works are among the most resolved and confident of Cézanne's pictures. The horizontal organization of the composition is divided into four parts; the area around L'Estaque, the gulf, the distant mountains, and a passage of sky. Shadow and modelling are eliminated. Thinly applied pigment produced the smooth surface so unlike much of his early work. It is color that suggests depth and flatness in Cézanne's mature paintings. The rich, static quality of the water currents in the gulf, obtained by using deep-blue pigment probably mixed with lead white, certainly differs from the typical "Impressionist" treatment of the sea as reflective light. The brushwork is carefully controlled but more intuitive than his so-called directional facture of the 1870s—horizontal, vertical, and curved stokes contribute to the structure of the paint surface.

Since Cézanne signed no more than sixty-one of his canvases (which number about one thousand), the absence of his signature does not necessarily mean that he considered this picture to be a study or unfinished.

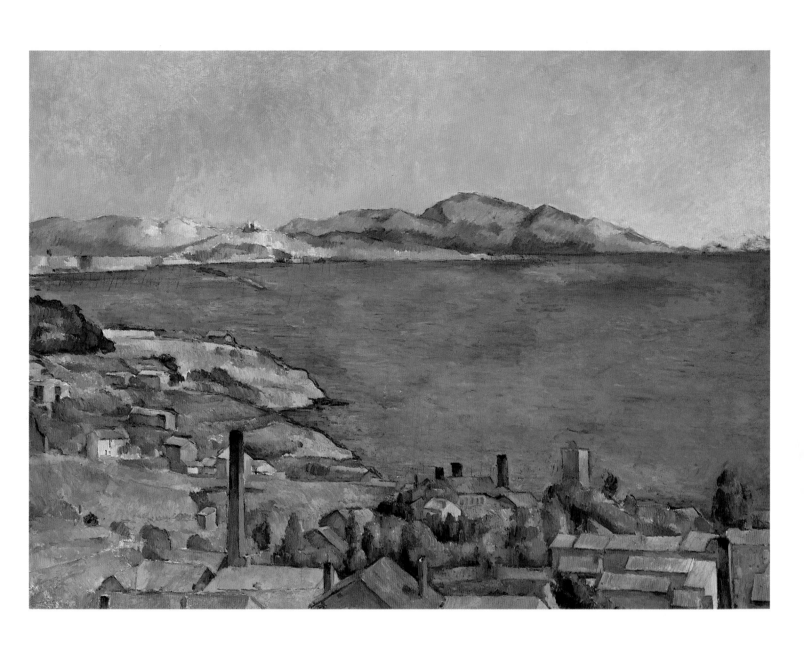

The Millinery Shop

EDGAR DEGAS

Milliners, like dancers, would surely have been considered unusual subjects for serious painting, for high art. Although there were numerous graphic depictions of milliners throughout the nineteenth century, no artist before Degas had subjected them to such a systematic investigation. Between 1882 and 1886, Degas explored the motif of milliners at work in drawings, pastels, and paintings. *The Millinery Shop* is the largest of his paintings on this theme from this period. Distinguished by her pale profile and sober olive dress, the milliner in this painting is placed on the right margin of the composition, tending to her craft with a pin in her mouth, held with pursed lips, as she stitches a hat. The finished hats, displayed on stands of various heights, compete with the figure for our attention. As is typical of Degas, his compositional asymmetry introduces an enigmatic quality into prosaic subject matter. Preparatory drawings reveal that he originally had intended his figure to be a customer but changed her to the milliner in the course of the painting's execution.

In the late nineteenth century, the milliners' profession bore a variety of connotations. In popular visual culture, prints, and the like, milliners were often presented as seductive women easily available for casual liaisons. At the same time, the skill required by their profession also offered them both the highest salaries of women in the work force and the respect due their craft. Despite the long and grueling hours required to satisfy demand at the peak of the fashion seasons, by the 1880s the ability to manufacture hats mechanically represented a threat to private milliners because factories were better able to fill the needs of an increasing mass market. It is possible to interpret Degas's painting as a highly personal response to the associations surrounding the milliners and their craft. The model in the picture is an attractive young woman, but, by placing her behind a table and focusing her attention on her work rather than the presumably male viewer, Degas seems to subvert the notion of the milliner as an object of easily accessible sexual pleasure. The intense concentration of the woman in *The Millinery Shop* and her exacting standards (so we assume) displayed by the products on the adjacent table convey a quality of respect that Degas does not always demonstrate toward his female subjects. Finally, there is a sense of intense loneliness and isolation in this painting. Perhaps the talented milliner anticipates her displacement.

The overall tonality of *The Millinery Shop* is muted and restrained. The table and background are thinly painted, allowing the ground to show through in various passages. The hats are presented in stiffly brushed color that vividly contrasts with the sobriety of the background. The surrounding is austere, but the hats glow with radiant color. This combination of various stages of resolution is typical of Degas's later work.

The Millinery Shop.
Edgar Degas.
About 1882–86.
Oil on canvas.
39 3/8 × 43 9/16 in.
(100 × 110.7 cm).
Mr. & Mrs. Lewis Larned
Coburn Memorial Collection,
The Art Institute of Chicago,
Chicago, Illinois.

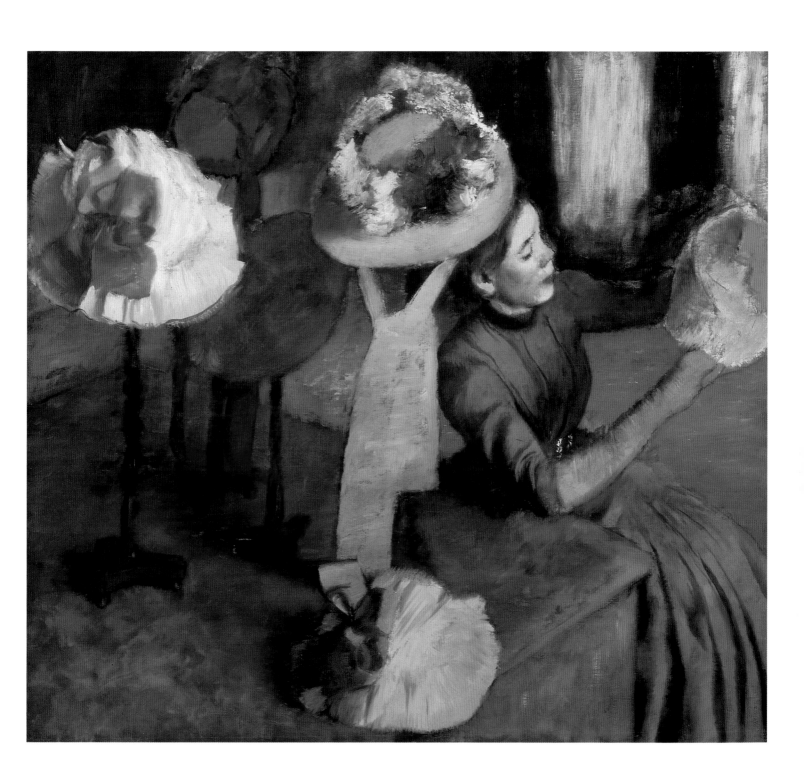

Sunday Afternoon on the Island of La Grande Jatte

GEORGES SEURAT

Georges Seurat was born in Paris on December 2, 1859. In 1878 he passed the entrance exam for admission to the École des Beaux-Arts, but his studies were interrupted by a year of military service in 1879. After returning to Paris, Seurat purchased a copy of Ogden Rood's *Scientific Theory of Colors*, early evidence of his interest in contemporary pictorial theory.

Seurat exhibited at the Salon for the first time in 1883 with a drawing. In the spring of that year he began to work on an ambitious large-scale picture entitled *Bathers, Asnières*, now in the National Gallery, London. The picture was rejected by the Salon jury. In response to the conservative policies of the Salon, Seurat and other painters created an alternative annual exhibition, the Salon des Indépendants, in 1884, where he exhibited his *Bathers, Asnières* at the inaugural show. Seurat exhibited his second large-scale picture, *A Sunday Afternoon on the Island of La Grande Jatte*, at the eighth—and ultimately the last—Impressionist group exhibition in 1886.

La Grande Jatte is an island in the Seine opposite Courbevoie, a northwest suburb of Paris, about midway between the Gare Saint-Lazare and Argenteuil. Easily accessible from the capital, the site became a popular retreat where people from the city came to row on the river or simply stroll along its banks. Sharing their leisure time, a variety of classes would mingle together. The development of this type of bourgeois sociability was debated at the time. For some observers such as Félix Fénéon, the island in Seurat's picture represented "a fortuitous population enjoying the fresh air among the trees." But Alfred Paulet viewed such activity as "the tedious wandering of a banal promenade of people in their Sunday best, who take a walk, without pleasure, in the places where one is supposed to walk on Sundays." Like Manet and the Impressionists, Seurat was deeply engaged with the subject of modernity. Seurat's intended meaning for this painting is not known, but the picture does convey the anonymity and ambivalence of modern urban life.

About thirty preparatory drawings and an equal number of oil studies for this painting indicate Seurat's ambitious intentions in its conception and realization. The pioneering technique developed by Seurat was based on dotting pure colors on the picture's surface and carefully juxtaposing specific colors. In addition to Rood, Seurat was interested in the writings of Eugène Chevreul, whose optical theory emphasized that the appearance of a color is altered by changing its adjacent colors. Further, Chevreul stressed that the intensity of a color is enhanced when placed next to its complementary color (a hue considered to be in extreme contrast to the other—for example, red and green, yellow and violet, and blue and orange). In theory, an optical blend of these colors would take place in the eye of the viewer, the so-called law of simultaneous contrast, but the dots used by Seurat were not small enough to fuse in the eye of the viewer. In response to Seurat's painting the critic Fénéon used the term Neo-Impressionist to describe the artist's efforts. The style is also known as Pointilism or Divisionalism.

Sunday Afternoon on the Island of La Grande Jatte.
Georges Seurat.
1884–85.
Oil on canvas.
81 1/2 × 121 1/4 in.
(207.5 × 308 cm).
The Art Institute of Chicago,
Chicago, Illinois.
Helen Birch Bartlett
Memorial Collection.

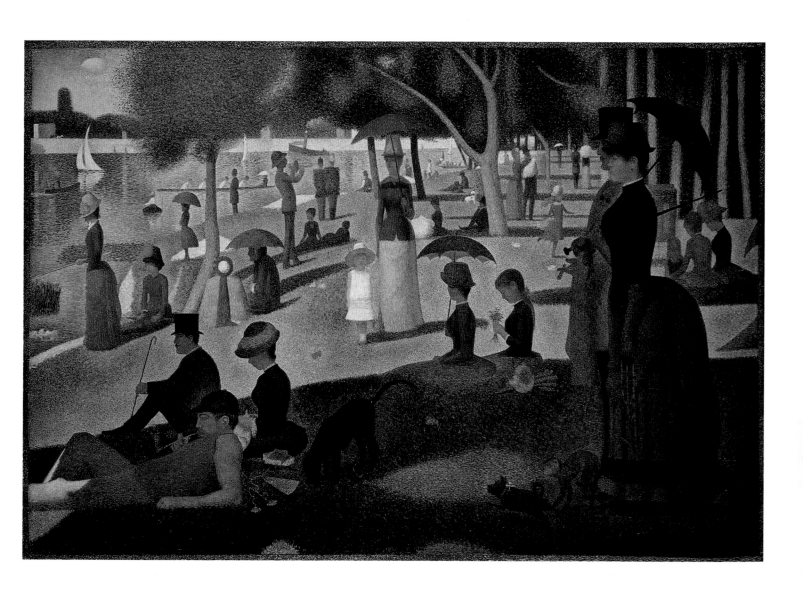

Georges Seurat.
A Sunday on La Grande Jatte.
1884.
Oil on canvas.
81 ¹¹/₁₆ × 121 ¹/₄ in.
(207.5 × 308 cm)
Helen Birch Bartlett Memorial
Collection, The Art Institute
of Chicago.

Corner in Voyer-d'Argenson Park at Asnières

VINCENT VAN GOGH

The son of a Protestant clergyman, Vincent van Gogh was born on March 30, 1853, in Groot-Zundert, the Netherlands. Three of Van Gogh's uncles were art dealers: he worked for them in The Hague, London, and Paris. Following an emotional crisis, Van Gogh was dismissed in 1876. He resolved to devote his life to the poor, studying to become a clergyman himself. After abandoning this effort, he moved to the mining district of Borinage in Belgium, where he attempted to help the exploited miners and their families. Around 1879, Van Gogh decided to become a painter, enrolling in a drawing class in Brussels. Early in 1886 he moved to Paris, where he lived with his brother Theo, who worked for the Goupil Gallery, which later became the Boussod and Valadon gallery. Theo would provide moral and financial support for his brother during the remainder of his life. In 1886 Van Gogh met Henri Toulouse-Lautrec and Émile Bernard. Theo introduced his brother to Pissarro, Degas, and other avant-garde artists in Paris. Rejecting his early dark palette and academic training, Van Gogh embraced the vibrant colors of the Impressionists and Neo-Impressionists.

It is likely that Van Gogh saw the eighth, and last, Impressionist group exhibition shortly after his arrival in Paris, including Seurat's *Grande Jatte* (see page 94) and several of Paul Signac's landscapes, as well as the fourth Salon des Indépendants, organized in 1887, which included Neo-Impressionist works by Seurat, Signac, Henri Cross, Lucien Pissarro, and several other artists. When he first arrived in Paris, Van Gogh experimented with Impressionist brushwork, principally in still life, but by the spring of 1887 he adopted a Neo-Impressionist facture.

Van Gogh had befriended the painter Émile Bernard, whose parents lived in Asnières, a favored site of Seurat and Signac. It is possible that *Corner in Voyer-d'Argenson Park* was painted in the company of Bernard or Signac in May 1887. The technique used in this picture is derived from Seurat's and Signac's meticulous use of dots of pure pigment. Van Gogh's handling of this technique, however, is looser and more intuitive than orthodox Neo-Impressionism. The size of Van Gogh's dot varies considerably, often more of a dash than a point of color, and his application of hue does not entirely conform to the concept of the "law of simultaneous contrast" fundamental to the Neo-Impressionist's methods. The painting can also be seen hanging on the wall above three empty tables in the artist's *Interior of a Restaurant*, painted during the summer of 1887, now in the Kröller-Müller Museum at Otterlö.

By 1888 Van Gogh abandoned Paris for Arles. He also abandoned his Impressionist and Neo-Impressionist styles, forging his own powerful and uniquely personal manner. He continued to remain committed to painting out-of-doors, but pushed the expressive possibilities of color farther than any of the artists now considered Impressionists. Van Gogh later advised an aspiring painter: "It is just as necessary now to pass through Impressionism as it was once necessary to pass through a studio in Paris." In another letter, he wrote: "I think that it is a real discovery [Neo-Impressionism]; yet it is already to be foreseen that this technique will not become a universal dogma any more than any other."

Corner in Voyer-d'Argenson Park at Asnières. Vincent van Gogh. 1887. Oil on canvas. 23 ⅜ × 32 in. (59 × 81.3 cm). Yale University Art Gallery, New Haven, Connecticut. Gift of Henry R. Luce, B.A. 1920.

Antibes Seen from La Salis

CLAUDE MONET

Antibes Seen from La Salis.
Claude Monet.
1888.
Oil on canvas.
28 7/8 × 36 1/4 in.
(73.3 × 92 cm).
The Toledo Museum of Art,
Toledo, Ohio. Gift of Edward
Drummond Libbey.

When Monet first arrived in Antibes in January 1888, he was unimpressed by the celebrated seaside resort, writing: "It may be beautiful but it leaves me cold." Yet he remained at Antibes and Juan-les-Pins through April, painting approximately thirty-six pictures along the Mediterranean coast.

The intense sunlight of the Côte d'Azur once again challenged Monet's *plein-air* painting techniques. He wrote to the sculptor Auguste Rodin on February 1, 1888: "I'm fencing and wrestling with the sun. And what a sun it is. In order to paint here one would need gold and precious stones. It is quite remarkable." And, in a letter to Berthe Morisot: "It's so difficult, so tender and so delicate, while I am so inclined to brutality." The coast along the Baie des Anges at Antibes lacks the natural drama of Etretat and Belle-Ile, where Monet painted spectacular seascapes in 1886. In a review in 1887 of an exhibition of these earlier paintings the critic Joris-Karl Huysmans characterized them as "a series of tumultuous landscapes, of abrupt violent seas in ferocious tones . . . under enraged skies." Monet thus responded to the different character of the Mediterranean coast by altering his palette and style.

Monet here has used the traditional landscape device of a *repoussoir*, or foil, to structure his landscape: an olive tree in the right foreground. Across the bay, Antibes is seen against the Franco-Italian Alps, beneath a calm expansive sky. The rather conventional composition recalls the landscapes of Claude Lorrain and Corot. The painter's palette and handling of pigment in *Antibes Seen from La Salis* are, however, decidedly unconventional. During the 1880s Monet adjusted his use of color and paint manipulation to his particular subject. The freshness and spontaneity of this picture are the results of careful deliberation. Various layers of pigment have been deployed over layers that had already dried, indicating several independent sessions before the motif. This contrasts with a loose and free handling of paint that would suggest, as it had in the past, a direct, immediate observation of a specific moment of a particular day laid down in a single sitting.

Ten of Monet's paintings from Antibes, including the present work, were exhibited at Boussod and Valadon's gallery in Paris immediately following his return from the south in June 1888. Although the Antibes paintings were a great commercial success, several critics (and artists) were unimpressed. In July 1888, the writer and critic Félix Fénéon wrote of Monet: "Well served by an overdone bravura of style, the productivity of an improvisor, and a brilliant vulgarity, his renown is growing, but his talent does not seem to have made any studies." Monet's friend Pissarro held essentially the same opinion: "I've seen the Monets. They are lovely, but Fénéon is right, good as they may be, they are not the work of a sophisticated artist." Even Van Gogh, who had received an account of the show from his brother, was dubious. After he had read a review of the exhibition by Gustave Geffroy, Vincent wrote to Theo: "He criticizes the Monets very ably, begins by liking them very much, the attack on the problem, the enfolding tinted air, the color. After that he shows what there is to find fault with—the total lack of construction, . . . so always and everywhere from the standpoint of lots of natural laws, he is exasperating enough."

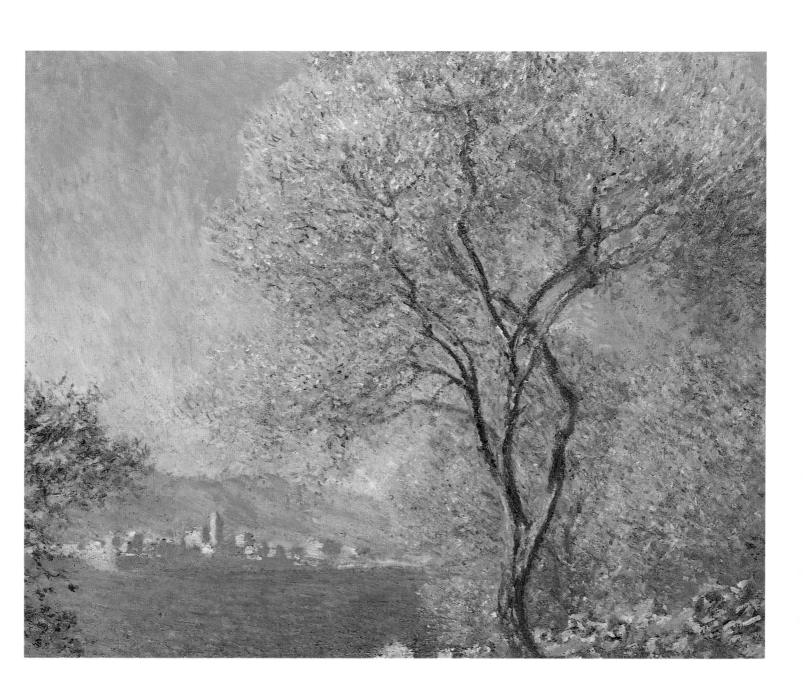

Grainstack (Snow Effect)

CLAUDE MONET

By the mid-1880s sales of Monet's paintings were increasing due largely to the efforts of private art dealers, particularly Paul Durand-Ruel and Georges Petit. Monet no longer required the public's attention to sell his work at either the Salon, where he never exhibited again following 1880, or at the Impressionist group exhibitions, declining to participate in the eighth, and final, group exhibition in 1886. During the final decades of the nineteenth century, Monet's national and international reputation steadily grew; he exhibited in Brussels, London, and New York. Nor did the painter need to seek out individual collectors since a variety of dealers sought to obtain large numbers of his works. In February 1889, Georges Petit offered to organize a joint exhibition of Monet's and Auguste Rodin's work in conjunction with the Exposition Universelle to be held later that year. The dual retrospective was a tremendous success. Monet played a significant role in the show's realization, by contacting collectors, retouching pictures, selecting frames, and contributing to the show's installation at Petit's fashionable gallery. Ultimately, the exhibition included 145 of Monet's paintings and 36 of Rodin's sculptures. By 1890 Monet was financially able to purchase the home and property he had been renting at Giverny since his move there in 1883. Thereafter he devoted himself to motifs near his property. He turned to local landscapes, beginning a group of pictures—conceived as a series—in late August or early September 1890.

There are at least thirty-five paintings of stacks of grain known today from the campaign of 1890–91. During the 1880s Monet often painted several pictures of the same site under varying conditions of light and atmosphere, such as Antibes in 1888 and the Creuse valley in 1889. Indeed, Monet installed paintings of the Creuse valley subjects as a group in his retrospective with Rodin in 1889. Monet's serial imagery represents, therefore, an extension of his Impressionism rather than a significant change of direction, such as when he abandoned the subject of modernity during the late 1870s. Monet articulated his intentions to the critic Gustave Geffroy in a letter dated October 7, 1890: "I'm hard at it, working stubbornly on a series of effects (grainstacks), but at this time of the year the sun sets so fast that it's impossible to keep up with it . . . I'm getting so slow at my work it makes me despair, but the further I get, the more I see that a lot of work has to be done in order to render what I'm looking for: 'instantaneity', the 'envelope' above all, the same light spread over everything, and more than ever I'm disgusted by easy things that come in one go. Anyway, I'm increasingly obsessed by the need to render what I experience."

Grainstack (Snow Effect).
Claude Monet.
1890–91.
Oil on canvas.
25 3/4 × 36 3/8 in.
(65. 4 × 92.3 cm).
Museum of Fine Arts, Boston.
Gift of Misses Aimée and
Rosamond Lamb in Memory
of Mr. and Mrs. Horatio A.
Lamb.

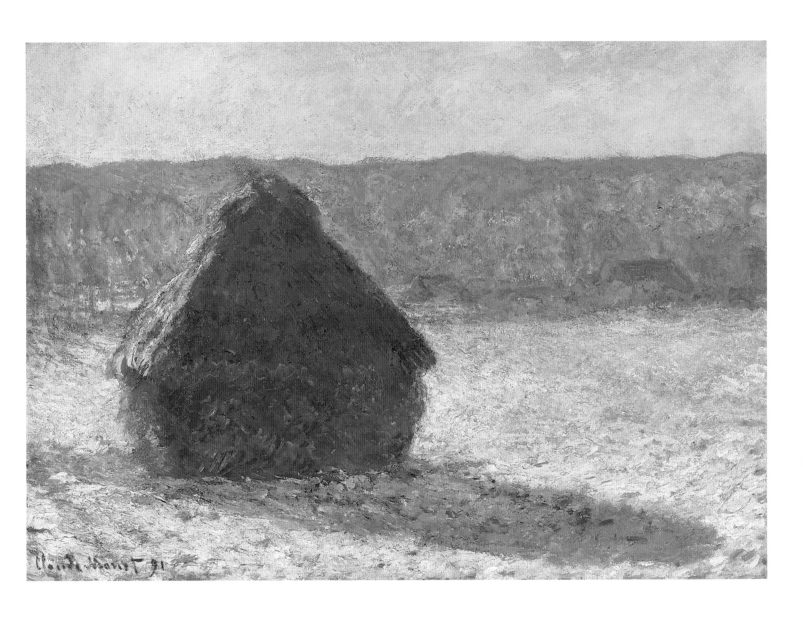

Pagans and Degas's Father

EDGAR DEGAS

Pagans and Degas's Father.
Edgar Degas.
About 1882, reworked about
 1893–95.
Oil on canvas.
42 3/4 × 44 in.
(81 × 84 cm).
The Scott M. Black Collection,
on extended loan to the
Museum of Fine Arts, Boston.

Portraits were one of Degas's major preoccupations, and during the 1860s and 1870s portraiture (constituting approximately one fifth of his work) provided the painter with some of his most profound challenges. Traditionally, portraits were commissioned, requiring the artist to present a flattering or at least sympathetic likeness of the sitter. Degas was not bound by this constraint. A private income had made it unnecessary for Degas to support himself at the beginning of his career by selling his work, and although the failure of his family's bank in 1874 diminished his resources, he nevertheless continued to enjoy modest financial security. Unlike Renoir, who could profit handsomely by painting appealing images of his patrons, and whose income depended on such patrons, Degas had no need to accept portrait commissions. He depicted instead his family and friends.

With the advantage of this freedom, Degas could also eschew the blank, nondescript backgrounds found in much nineteenth-century portraiture, choosing instead to present his subjects in the context of their actual lived experience. Degas's ambition was not simply to secure the likeness of his subject but rather to convey the physical, social, and psychological character of each sitter. In keeping with these intentions, the artist delved into both traditional and modern theories of physiognomy.

The subjects of *Pagans and Degas's Father* are Auguste De Gas, the head of the Paris branch of the family-owned bank, and Lorenzo Pagans, a Spanish tenor and guitarist. Pagans had performed at least one role at the Paris Opéra, but his fame and popularity derived from his performances of Spanish songs at various Paris soirées, including those held at the homes of the senior De Gas and Manet.

This picture is the last in a progressive sequence of three oil portraits of the same sitters. The first version, painted about 1868 and now at the Musée d'Orsay, offers a frontal view of Pagans playing his guitar, with Degas's father sitting in profile behind him. The next picture, done about 1869–72, now at the Museum of Fine Arts, Boston, presents the sitters in a more compact space. In this version, Pagans, again playing his guitar, is seen in profile, but the senior De Gas's pose remains virtually unchanged from the first rendition of the design. In the picture reproduced here, the last of the sequence, Degas has made significant revisions to the earlier portraits. Unlike the previous two, here he has applied the paint freely, in broad and loose strokes, and placed the figures in a much larger interior space. Rather than hold a guitar, the Spanish tenor reads a book; the guitar has been replaced with a piano. The foreground is occupied by a cloth-covered table with books placed on it, and this has the effect of complicating the space by putting a barrier between the viewer and the figures. The artist's father (who had died in 1874) again appears in the background. Although his pose is virtually identical to that in the first version (which hung in the artist's bedroom throughout his life), he appears to be lost even more deeply in contemplation, unaware of the presence of Pagans. Thus, compared with the two earlier versions, Degas's composition has become increasingly more complex and asymmetrical, setting forth an unusual spatial scheme in which the viewer now assumes a position above the figures.

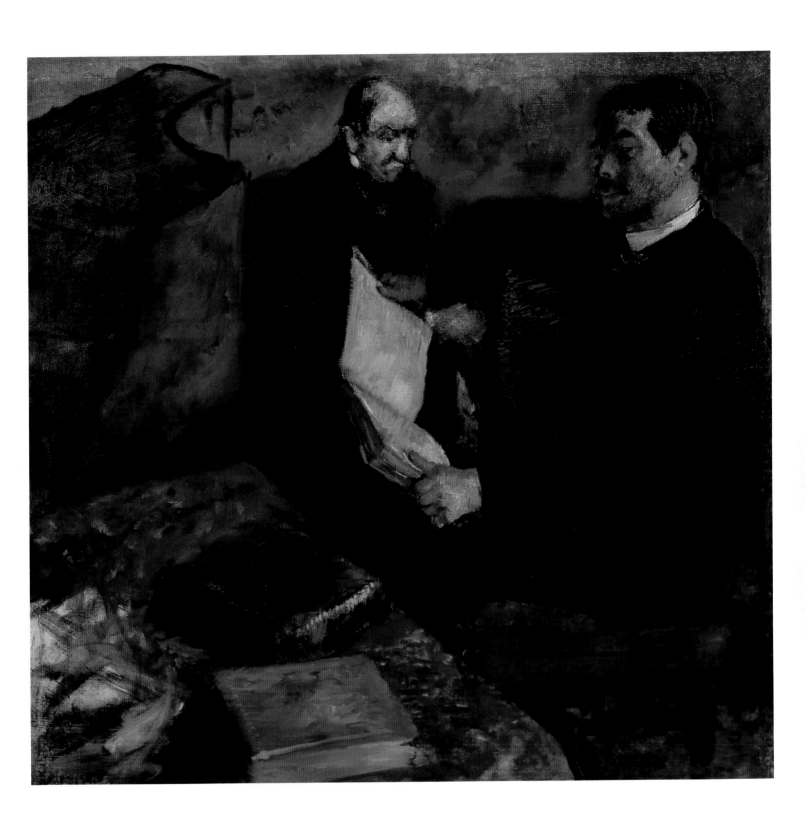

St-Charles, Eragny, Sunset

CAMILLE PISSARRO

During the spring of 1873 Pissarro and Monet together played a pivotal role in the formation of an exhibiting society—the Société Anonyme—as an alternative to the conservative Salon. Pissarro exhibited five paintings in the first exhibition sponsored by this organization in 1874. He would thereafter be the only member of the group to participate in all seven subsequent Impressionist exhibitions. Within the group, Pissarro remained on good terms with most of the original members in spite of their sometimes violent differences. Although Pissarro was loyal to the group exhibitions, by the late 1870s he had abandoned the seemingly spontaneous and fluid style of his early Impressionistic work in favor of more-complex compositions and methodical paint handling. Pissarro also responded positively to the Neo-Impressionism of Georges Seurat and Paul Signac, although this is often characterized not as an extension of Impressionism but as an aesthetic reaction against it. He advocated Seurat's and Signac's participation in the eighth Impressionist exhibition in 1886.

By 1891 Pissarro himself had backed away from these new tendencies and returned to the looser manner of the late 1870s and early 1880s. A successful exhibition of over seventy of his works at the Durand-Ruel gallery in 1892 provided the money, supplemented by a loan of 15,000 francs from Monet, to purchase a house and garden in Eragny, not far from Giverny. This picture was painted a year before Pissarro's final move to Eragny.

The spontaneous handling of pigment in Pissarro's *plein-air* canvases from the early 1870s is replaced by a dense, almost woven facture. Representing the play of light upon the luminous trees and field was a motif favored by Monet. Pissarro instead lays down a dense interlocking mesh of brushwork in his effort to capture the shimmering play of light at sunset. The palette of this picture is both intricate and subtle: Pissarro combines white pigment with tints of yellow, green, purple, and blue.

Although Pissarro and Monet continued to be interested in the effects of light and atmosphere in the 1890s, Pissarro's technique and conception of landscape painting differed from Monet's at this time. Monet's *Morning on the Seine, near Giverny* (see page 106) is characterized by a subtle but extremely restricted palette. While Monet painted a vaporous veil of atmosphere, Pissarro continued to imbue his landscapes with tangible material forms. During the 1880s and 1890s, Monet largely eliminated figures from his paintings. However, Pissarro, the more political of the two artists, continued to include people and was especially concerned with the individuals who toiled in his landscapes—though in this case there is but a single shepherd and his flock, hardly noticeable in the field.

St-Charles, Eragny, Sunset.
Camille Pissarro.
1891.
Oil on canvas.
32 × 25 ½ in.
(80.8 × 64.9 cm).
The Sterling and Francine
Clark Art Institute,
Williamstown, Massachusetts.

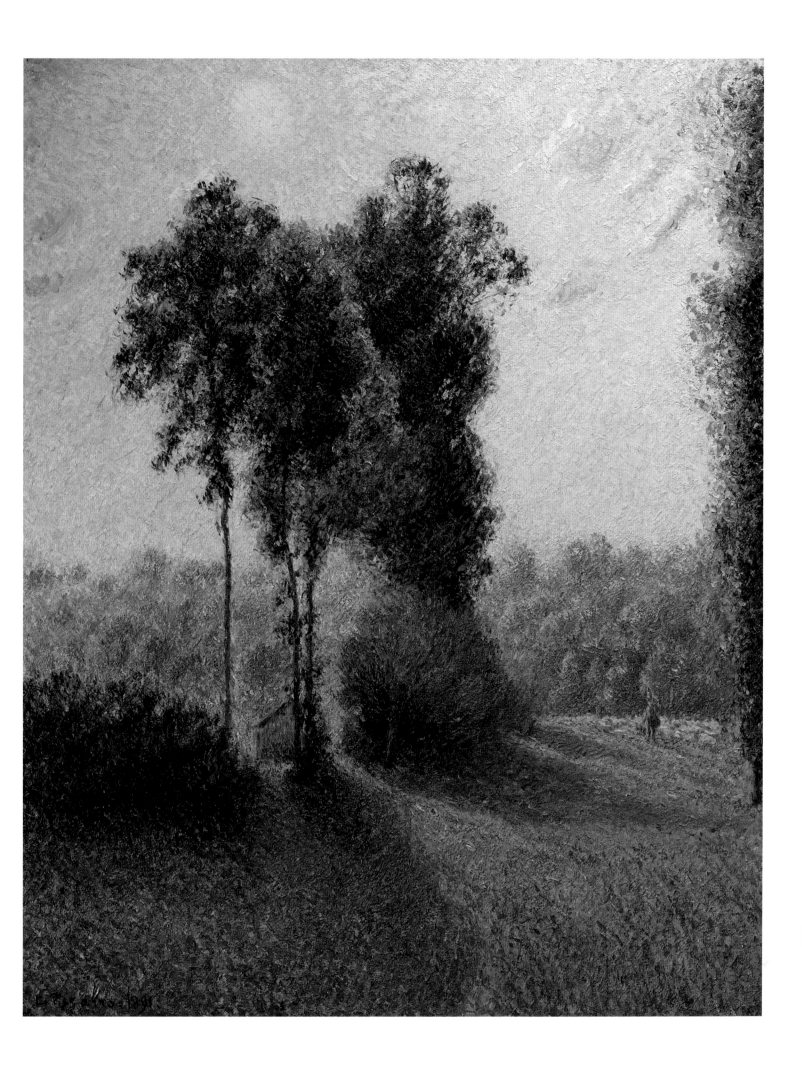

Morning on the Seine, near Giverny

CLAUDE MONET

eginning late in the summer of 1896, Monet rose at 3:30 every morning in order to realize a series of paintings of the Seine at dawn. The final result was a group of twenty-one pictures characterized by remarkably nuanced observations of light and its reflection on the water. Monet painted *Morning on the Seine, near Giverny* from the same flat-bottomed boat he had used for his earlier series of poplars. The series of canvases renders the rapidly changing light at this time of day. The painter-journalist Maurice Guillemot characterized Monet's work on the series as "prolonged, patient labor, . . . anxiety, . . . conscientious study, [and] feverish obsession." In theory, as the paintings were executed in a series of one for each hour of the day, the entire group could be organized so as to convey the increasing luminosity of the rising sun.

Morning on the Seine, near Giverny was probably painted at dawn's first light. There are only faint hints of the green summer foliage. Monet's color and brushwork are rarely more integrated than in the *Morning on the Seine* series. Despite his aim of objectively rendering the particular effects of light, the paintings in this series appear to be extremely subjective responses to his motif.

The hazy atmospheric ambience of the series recalls the work of Camille Corot and his concern with rendering *effets* (effects). The American artist Lilla Cabot Perry described the series as having a certain Corot-like quality, "Corot having been fond of painting at that [pre-dawn] hour." The critic Arsène Alexandre maintained that the group "gives the impression of light, refined joy, . . . [and] well-being one can find, these days, only in the paintings of Corot." This painting is one of the first in the series and was among the seventeen versions of the motif exhibited in Monet's much-acclaimed one-man show at Durand-Ruel's gallery in June 1898.

Morning on the Seine, near Giverny.
Claude Monet.
1896.
Oil on canvas.
29 × 36 5/8 in.
(73.8 × 93 cm).
Museum of Fine Arts, Boston. Juliana Cheney Edwards Collection.

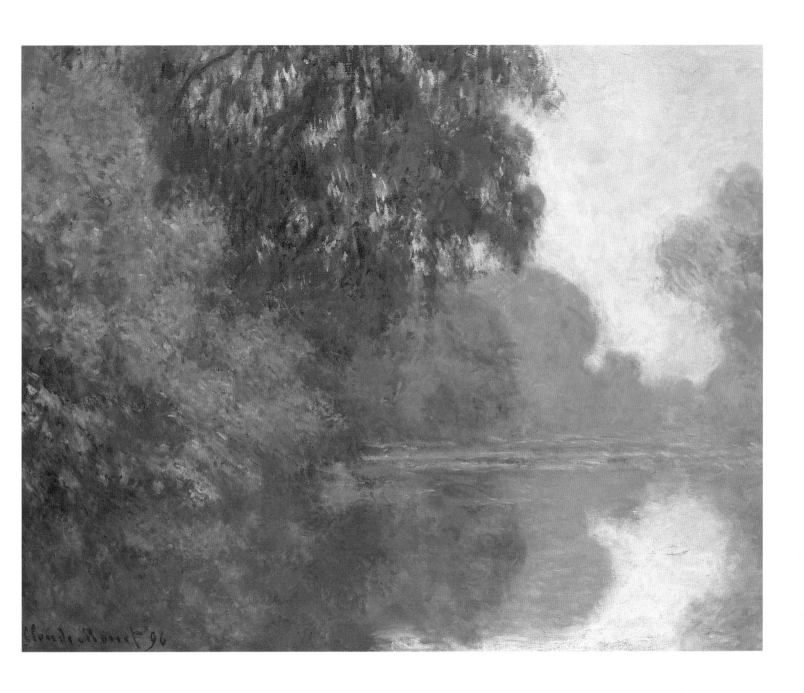

Mont Sainte-Victoire

PAUL CÉZANNE

A mong Cézanne's landscapes, his depictions of Mont Sainte-Victoire are perhaps his most personal and ambitious canvases. Cézanne was raised in the shadow of this mountain. Its name is believed to be derived from the victory of Marius over the barbarians in the first century A.D. According to legend the river Arc at the base of Mont Sainte-Victoire, where Cézanne and Zola swam together as adolescents, ran red with blood after this ferocious battle. Located to the east of Cézanne's birthplace at Aix-en-Provence, the mountain dominates the surrounding landscape. Cézanne painted Mont Sainte-Victoire often between 1882 and 1890, and then again between 1901 and his death in 1906.

In 1902 Cézanne had a studio built in the hills north of Aix called Les Lauves. The vantage point from his location offered the most dramatic views of the mountain's imposing profile. Cézanne painted at least eleven canvases and numerous watercolors from the area near his studio at Les Lauves. Each of the eleven canvases is unique. *Mont Sainte-Victoire* was undoubtedly painted *en plein air*. The differences in mood and character found in the paintings of this subject are perhaps related to the conditions under which each canvas was realized. In the present picture the vibrancy of Cézanne's brushwork seems more confident than in the other renderings of this subject. Loose strokes are tightly deployed upon the surface. The picture is composed of bold *taches* (touches of paint) more freely applied than in his earlier work from the 1890s. It is a highly personal touch unique to the hand of its maker. The *taches* result in a mosaiclike effect. Cézanne's restricted palette is primarily composed of yellow ochre, cobalt blue, viridian, and emerald green. The contrast between the ochre and green strokes animates the sloping meadow that leads to the mountain's base.

Extremely sensitive to color harmony, Cézanne's palette abruptly changes for the mountain and sky, which are painted in various hues of blue and gray. In the upper portion of the canvas, Cézanne incorporates green to complement the lower half of the composition. Optically, the warm colors of the foreground appear to advance and the cooler shades used for the mountain and sky to recede: the result is not jarring but, rather, representative of Cézanne's extraordinary ability to manipulate color.

Perhaps more than any other subject, Mont Sainte-Victoire provoked the inherent contrast and conflict in Cézanne's art between the objective recording of a particular landscape and the painter's subjective response to his subject.

Mont Sainte-Victoire.
Paul Cézanne.
1902–1904.
Oil on canvas.
28 3/4 × 36 1/4 in.
(73 × 92 cm).
The Philadelphia Museum
of Art, Philadelphia,
Pennsylvania. The George W.
Elkins Collection.

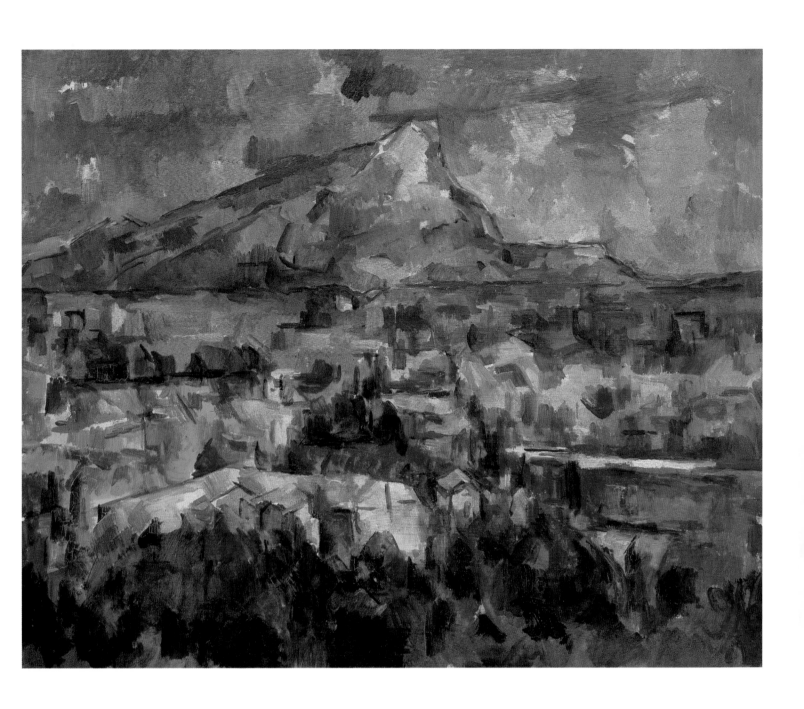

Index

Page numbers in *italic* indicate illustrations.

Photo Credits